THAT FIRE OVER THERE

Prem Sahib

Book Works

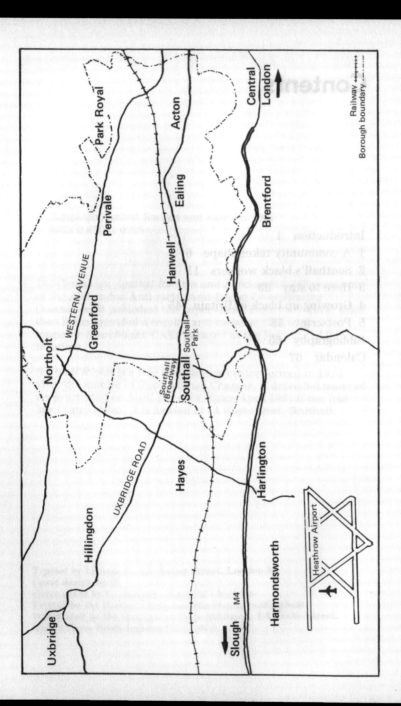

Preface

There are man
of decaying in

The labour
helped first to
to recovery. Bl
transport servi
vice, worked th
dustries and he
Marshall Plan,
was founded. A
perity, from a s
housing afford
live midst the c

But from th
stonecrop, iron
ing racism of g
– with little m
brought with t
munities.

And it is the
binds the com
Side, Lumb Lar
go' areas for pc

i.
PEOPLE COME & GO

ii.
CUL-DE-SAC

iii.
MAN DOG

MILOVAN FARRONATO
24 March 2020

Dear Prem,

Late, deep night; we were into a second or third evening, maybe even a fourth. (How many evenings are there before dawn comes? How many segments can a night be divided in?) I don't remember where we came from, but I remember the taxi ride. You invited me, on this unexpected and frugal visit, to consider some of your iconographic and environmental references. You were unable, however, to find the entrance to the night club, our last destination. Could you locate it online? Perhaps the place was too niche, with specific customers. You asked the driver to abandon us at a corner of Baker Street (I think) and then, neurotic as usual, you began to take me back and forth along a cluster of streets close to the same block. I feared for my high heels, but I knew that if I needed to, I could swap into your classic sneakers (do you always wear the same ones, or have several of the same model?). We finally managed to locate the entrance. We had probably already passed it. It announced itself with a single sign, blue like some of your neons. Thick walls and darkness. A man no longer young appeared behind a fogged glass. He first asked for a card payment, warmly encouraged membership, and subsequently, narrowing his gaze, informed me that I was not welcome. Men only! High heels, a touch or more of makeup, and it immediately became a question of gender. I imposed myself, and you supported me trembling. I had to assert my legitimate biological origins, beyond the construction of an image that pertains only to me and that can be variable. I dominated the 'gatekeeper of hell', who wanted to discriminate against me, and we finally managed to cross the fetid threshold.

Smoky, gloomy, labyrinthine. A man had lost everything inside. Perhaps he had undressed too quickly; he was now ranting, screaming, going round and round in only a shirt without briefs, willy dangling post-coitus. What better *captatio benevolentiae* for my baptism in a London

cruising club. I confess, it was a productive visit: I came across black mats for the first time, without slipping on them; those black mats with a ridiculous thickness. There was a fully padded and scarred-looking variant like the ones you acquired for your participation in 'Forget Amnesia', the fourth edition of the Volcano Extravaganza festival in Stromboli. Your contribution, *Boys in the Sand*, encouraged viewers to recline horizontally on these mats, while you played them a porno of the same title by Wakefield Poole. This was interrupted by a new soundtrack that you DJed, and by footage you'd shot on the island that mirrored scenes in the film. It actually brought that *en plein air* aesthetic, on the typically Aeolian *biasuolo*. Pindaric flight? *Pourquoi-pas*? The name of the club, The Vault, later became the title of your anal sex flavoured fragrance that we exhibited in the first location of the Fiorucci Art Trust in London, after a lengthy period of collective research into oils and perfumes. These clubs are closing everywhere little by little. Why do you want to preserve a melancholic, even romantic memory?

Milovan

2019-11-16 16:59:20

PREM SAHIB
30 March 2020

Dear Milovan,

The place you're describing is a small cruising club near Warren
Street. You could say that we've visited twice together now, since
you were also one of the first to enter my installation at Southard
Reid (*People Come & Go*), which was an exact replica of an
interior section of this club, re-made in the gallery space. A metal-
clad corridor drenched in red light led viewers in one direction
only, toward a tunnel where they would confront a white male
performer lying on one of the black wipeable mattresses you
mentioned – as though passed out, dead, or sleeping, seemingly
oblivious, fragile, abject. Irrelevant, perhaps? Everything was made
to scale, so for the duration of the exhibition two versions of the
club existed at the same time, only a mile apart. One obviously
functioned as it normally did, catering to guests who ventured
there, usually alone, to have sexual contact with strangers.
However, in my version, time stood still and an otherwise shielded
image remained more permanently exposed for anyone to witness.
Between the actual club and this facsimile, between the two
occasions of night and day, there was also the scent I produced
for your exhibition 'I am here but you've gone'. I recall this smell as
somewhat contradictory, because it both lured and repelled at the
same time. It was musky from the cumin and civet I used, which
in careful combination smelt like shit and sweat, masked with
sweeter notes like peppermint – reminiscent of cheap aftershave
and disinfectant, or the chewing gum of someone getting
uncomfortably close. Ultimately, this contradiction is not dissimilar
to my affinity with these spaces. They are places I sometimes want
to forget, but I clearly can't seem to leave behind. Maybe this is the
romance or melancholy you detect? A romance found in the most

unlikely of places, which has admittedly soured over time. You see, I have a sentimental attachment to clubs like these: they've been a rite of passage for me. But in recent years, I have also come to understand them beyond their seemingly transgressive potential. I ask myself, could they also be a trap? I hate how your presence was questioned that night. It's not the first time it has happened to us, crossing from one world into another. A similar situation occurred on our excursion to a mega cruise club for bears, which has also since closed. Here the gatekeeper directed his message through me, whispering, 'you'll have to tell your friend to remove the lipstick'. Perhaps he was too ashamed or intimidated to tell you directly? Maybe it's because I passed as a 'man' in his eyes, someone adhering to the contract of the space, but in truth I am not. In many of these places freedoms are played out within boundaries – be they binaries, uniforms, codes or tribal alliances that help draw parameters of comfort or alienation. The veneration of certain 'types' reflects a deeply ingrained economy of desire that insidiously maintains a particular version of what constitutes a man. But I have equally witnessed expressions of identity, defiance and community that aren't given space in the world above these stinky basements, where public, private and secret selves converge, albeit only for those who are granted access.

Like you say, many of these spaces are closing: mini deaths happening all around the city. To answer your question more directly, I'm interested in what these ruins might tell us about the nuances and contradictions of community and self, and how these are reflected more broadly in society through constructions of gender, sexuality and race. Preserving something means it can exist in situations that are divorced from its original context, challenging the authority of where it came from as well as the situation it exists in now. It means one world can infect another.

Amidst the industrial surfaces of the cruise club – materials such as the grip metal, scaffold and chains – I am always seduced by the pattern of men's shirts which, in contrast, gently delineate lines that come together like mesh: checks, stripes and bars worn unknowingly on backs. Like the kind of shirt that the guy who had lost his trousers was wearing, presumably coming straight from the office, into this third space, neither work nor home, maybe hoping to exercise some release, only to panic when things went

too far; when the material possessions he shed momentarily vanished completely. I remember that he thought someone had stolen his clothes. How would he now leave this constructed world, this theme park, and return to normality, back to his partner or wife, if not in the uniform in which he came?

When you leave this club, you directly face a sports court, a giant cage-like structure where bodies perform for others to watch. Exemplary artefacts, like the body I had slumped at the end of the tunnel. Is the game they play with a ball that much different to the cryptic moves I taught my performers last summer as they revealed and concealed themselves behind columns in the archaeological site of Pompeii?

As I write to you from quarantine – captive you could say, in my own domestic environment, I continue to contemplate some of these questions about our perceived sense of self, where our bodies begin and end and the spaces that afford us 'freedom'.

Prem

PREM SAHIB
27 April 2022

Dear Ashkan,

I've been meaning to write to you and start this conversation for
some time now. I wanted to ask you about WHITEHELL. I first saw
this word in one of your drawings and it immediately struck me as
describing something familiar – like a place I had been. It felt as
though I had muttered this word to myself in certain situations, as
if summoning a reality into existence, a reality which, by naming it,
became more bearable to endure – a bit like the power you have
over a demon once you know its name.
 Does WHITEHELL have anything to do with the spaces I know
we've both moved through? There was a time, mostly in Berlin,
when I used to see you more in the dark than I do now. I have this
memory of your silhouette appearing through an internal brick
aperture with a flickering light highlighting parts of your body. I
think I was standing in a darkroom at the time. It's strange how
the dark can both hold you and feel boundless, giving space to
apparitions and tricks of the eye, all between the interruptions of
flesh and bone.
 Some of the spaces I would see you in required us to be a man
to get inside. It's weird thinking back, because I swear I would hear
voices carried over the tops of cubicles that seemed to contradict
the scrutiny of the door policy; voices that restored some of
what was taken away when you entered that space. From inside
a cubicle, you could hear disembodied pitches and tones that
brought the pageantry of the MAN, singular, into a blurry refraction.
 Once, at a party, I remember us hugging all sweaty, hairy and
high, screeching into each other's ears 'WE ARE ISLANDS', before
we drifted apart again back into a sea of mostly white bodies.
We spoke about that moment when you interviewed me for *Phile*

Magazine. I don't know if you know this, but that conversation was published a few days before my dad passed away. I remember trying to post something about the article on Instagram while at his bedside. I thought this was days before he died, but it turns out it was the same day, 2 November 2018. I can't believe I was on Instagram... I can only imagine I was trying to maintain some semblance of normality and connection to my past life, as life in that room slowly slipped away.

I still don't have the words to explain that situation, but there are sensations and images I will never forget; the phantom impression that lingers from holding a hand for so long, the weight of a head that requires gentle manoeuvring, or the mirage-like heat that evacuates the body through the nose as final breaths are taken. What was that even? It appeared to dance slowly out of the nostrils, as if leaving the depths of a cave, smudging the outline of everything around it as it left.

Anyway, death. We also share the closeness of that together in a club. But I don't know if this is something you want to talk about here?

So back to WHITEHELL.

I feel like something inside me had to die for me to realise I'd ended up in WHITEHELL. I feel stupid for not allowing that death to occur sooner. I mean, I experienced signs of it all my waking life. Perhaps that's the paradox of being made to feel invisible by the invisibility of whiteness?

When I saw you visit my installation *People Come & Go*, I was sitting in a pub with my phone in my hand. I was with a group of people, but I had this private moment where I could see you on the CCTV that was installed to make sure the performer was safe. I immediately wanted to know what you thought. I was desperate to know whether anything resonated with you through some of the shared moments we've had through our 'island positionalities'. When I think about it, that installation was a bit like trying to stare back into a dead end at the remnants of something I was trying to leave behind. But maybe there was something else lurking there to be found? A new encounter to be had in the passageway towards nothing.

Prem

ASHKAN SEPAHVAND
28 April 2022

Dear Prem,

Your letter's arrival is very timely. It was just yesterday that I was thinking about Hell, and it paralysed me. I think I've told you that I've been seeing a psychoanalyst now for a few months. Partially out of curiosity for the process, partially out of concern for recurring instances of extreme rage I've had in the last years. Proper meltdowns, not cute. Anyway, in this week's session I was talking about a film I'm making (we talk about art a lot) and she offhandedly dropped a reference to a text. I looked it up afterwards: the *Arda Viraf Nameh*, a ninth-century recension of an older, pre-Islamic narrative about a devout man, favoured by God, who journeys in the company of two angels to visit Heaven, Purgatory, and Hell. Very much *Divine Comedy* vibes, just the Iranian version.

So, I read the text, it's a bit boring as religious or medieval texts usually feel to be, but then I think, well, maybe it's just the English translation. On YouTube I find an audio book version in Farsi, recited by an Iranian poet I've never heard of, a man with a nice voice that reminds me of my father. I put it on and go about my morning routine. I'm anxious and excited to get to Hell, the most detailed part of the text (just like in Dante). You see, the first group of sinners the narrator encounters in Hell are the sodomites. Their punishment is to have snakes enter their bodies through their mouths and exit through their assholes, or the other way around. In any case, these men who have let other men 'enter them' suffer from a ceaseless, cyclical, slithery penetration, forever ass-to-mouth; they endure a kind of infernal ouroboros.

I'm curious what Farsi word is used for 'sodomite' and so, bored of Heaven, I fast-forward to Hell. The poet recites the scene and then pauses, taking an aside to explain the word, 'مواجران'. I hear discomfort and embarrassment in his voice, he can't really bring himself to say it. He mumbles and stutters and rushes, all the while trying to retain an orator's

proper countenance: 'Well, here the reference is to... well... men who... men who... lay with other men, which as you know, in most religions is frowned upon, anyway moving on!'

Initially, I find the whole thing very amusing, this personal lapse in the reading, how (not-so) subtle disdain and disapproval emanate from his cursory explanation. It's a double whammy: the text damns us, the poet damns us, and this begins to irk me. Maybe I'm being oversensitive? I decide to Google the word مواجران and find very little out there. After all, there is still somewhat of a cultural taboo around sexual vocabulary in Farsi. There is a vaguely written definition with usage examples in the Dehkhodah dictionary. With my broken grasp of the mother tongue, I can't make much of it, so I put it through Google Translate. The example I choose gets me the following sentence: 'a disgrace and an illness that has made you a donkey more than a thousand times.'

Then it hit me. You know how they say the 'work of analysis' takes place between sessions? Well, these associations I've just shared literally opened the Gates of Hell.

I felt shame, Prem.

It surrounded me, it was overpowering, and it was a very old feeling. I think it was the word 'donkey' that triggered it. I could hear my father's voice saying it. His voice merged with that of the poet who couldn't bring himself to describe sodomy. I felt deep shame, maybe not so much *for* but *within* my sexuality. It took me off guard because I've always thought that the intersection of shame and sex is a white people thing. You know, like Judeo-Christian after-effects that conjugate on some plane of desire into silly social forms I've never really been able to get into, like sub/dom, top/bottom, and all the weird and stupid 'kinky' stuff involving use, abuse, bondage, gear, degradation, piss, fist, whatever. Ok, so even if none of that is my thing (I guess? Am I afraid to admit it?), the shame endures, and I couldn't deny it anymore.

You know, I grew up with my father reciting poems to me. Our relationship has always been difficult, but this is the memory of him I have and hold most preciously: his love of poetry, his voice, his explanations, line by line, word by word, which I'd never really listen to – 'ugh, there he goes again' – but that have shaped my sensibilities. He still does it every now and then. These are the only times I can say that we are, perfectly, intimately close. Just last week he sent me a short piece by Sohrab Sepehri, about a father who recites a poem to a son. Afterwards, the son thinks to himself about life and death. I'll share my translation of the last

line with you: 'life is the weight of a glance that remains in remembrance.'

My father tried to kill himself six months after I came out. Or rather, it was quite the dramatic performance and I'm not sure if he really intended to go through with it. It was my first week of college in New York and I was finally going to be on my own. He had come to help me move in, despite having had a workplace accident that summer, a gunshot to the knee. I had come out in the spring, I really hadn't planned on it or thought it was necessary, but it happened. My father reacted relatively cool. He intellectualised it. Then the accident happened, and he was bedridden, so we spent the summer hanging out, talking about books, and smoking opium together (painkiller, lol). He randomly told me stories of his virile youth, sexual prowess, and marital misgivings. These legendary boasts intensified when we arrived in New York. A few days before having to say goodbye and let me go, everything changed. He had a meltdown in the hotel room, called me all sorts of names (probably 'donkey'!), invoked God (he's an atheist) and lamented the shame that has befallen our lineage. He then took a bottle of morphine pills and emptied it into his cupped hand. Twenty to twenty-five pills or so; he said he'd swallow them all and just end it now, what's the point of living on with such a disgraceful son in the world. I coolly, calmly, surreally approached him and kicked him in the wounded knee. He doubled over in pain and the pills dropped to the floor. I took away his pharmakon, dragged him into the car, drove him to a hotel near the airport, checked him in, and told the receptionist to make sure he didn't miss his flight back to Tulsa. We didn't speak for half a year and once we did, we never acknowledged what had happened. We have never spoken about my sexuality again. After college, I moved to the other side of the world. He asks me sometimes why is it that I'm so far away.

Was this the shame I was feeling now, finally? The shame he invoked then like a curse or banishment, the shame I had resolutely refused to feel with him, because I needed to go out into the world and become my own liberated person? Is this why I desire so passionately to move freely? And am I then now free? And if so, what kind of freedom is it? Am I free *from* or free *to*?

I realise this is all a very long-winded, intense, and indirect reply to your questions with more questions. And I don't have any answers, really. I can say, though, that WHITEHELL is a word-image I received after my own earth-shattering meltdown one summer in Athens. I violently kicked out my travel companions, screaming 'get out, get out, get out, leave me

alone!!!' It took me some time to grasp then that being alone is not the same thing as being lonely. I didn't want to be alone, I desired loneliness. All those memories you have of me in the dark, on my own, doing things with other men, pretending to be a man myself, knowing that my friends are nearby but insisting that I must go solo, I must keep moving, I was practising loneliness. And that notion of freedom I had embraced in those spaces, the freedom to be constantly and ceaselessly penetrated by other men, was the very foundation of this shameful solitude.

It turns out that in WHITEHELL, too, just as in otherworldly Hells, snakes go in and out of our holes all the time and this causes great suffering. In WHITEHELL, every death looks like it's its own fault. Why did this word-image come to me with such delay? It should have been clear already years before, for example, after that party in Berlin when I almost died from an overdose of GHB. You were visiting town then, we had gone out, I had separated from you, I wanted adventure, I went to the darkroom, the bathroom, the after-hour, seeking, drifting, and when you eventually found me, I was lying on a packed dance floor having a seizure. It was only you and 'Team Sweetie', our mutual group of brown friends (coincidence?) who noticed, who called the ambulance, who insisted to my white, German ex-boyfriend that no, I wasn't fine, I can't just be left in some corner, I won't eventually wake up and be ok. My heart had stopped, so you tell me, some raver was punching my chest. Did the paramedics have to use a defibrillator? I am ashamed you had to see me that way. I came to in the hospital and the first thought I had was, *let's go back out and dance, let's flirt, cruise, and fuck, what did I miss*? There will never be enough snakes.

I kept going back to the spaces of the men to exercise my freedom to be lonely, flirting with ruination, consuming death-droplets and reminding myself I should simply keep better measure of my dosages. Only years later, lying on a dirty floor mattress in Athens, after a month of men coming and going, each more brutal than the last, that these rambling lines bubbled up from my unconscious: 'this could be a fiction / some kind of sci-fi I guess / about a world ruled by the men in WHITEHELL / about a brown faggot who gets sent to a death fuck camp / about a writer from Tulsa, Oklahoma who summons a Persian demon / and I laugh because TULSA IS A SLUT SPELLED BACKWARDS.'

Were you thinking about this, or me, even, when you made *People Come & Go*? I know it might sound vain, of course, as the image of someone passed-out in a club, darkroom, or sauna is all too familiar. But I

can't help to wonder, since we shared this near-death encounter, whether in many ways that was the moment for us both when, as you identify so well, something else inside began to die. What I've always admired in your practice is how you translate your memories of these libidinal spaces we traverse into the 'weight of a glance', offering place as a presence. Your sculptures and installations have always felt for me like eerie-sexy relics or anti-climactic monuments of sorts. I remember connecting so strongly as we talked and met over the course of you developing *DESCENT* to a feeling of exorcism in the work, something I had been feeling in my own writing and performance, too. We were inviting the demons out, invoking their names, but they weren't necessarily evil creatures, more like ambivalent jinn, energetic forces that both create and destroy. Exorcism may not be the right word here, as I guess it assumes some ideal of recovery or purification afterwards. Maybe we are still exorcising, maybe it will never end, maybe this is a position that should be occupied for a while longer?

I know it's not really en vogue, culturally or discursively, to take *shame* as a position. It seems to me these days that much of what is officially termed queer/POC art and theory seeks to either heal or empower. To find an answer to the problem of WHITEHELL, I guess. Trauma can be repaired, the broken relationships mended, the shame renamed, the meanings of insults recast and re-commanded. 'We' are beautiful and brave, sex is positive, don't be a killjoy. It all seems like a grand exercise in forgetting to remember. *The ego is a liar.* I think what I'm trying to say is that in expressing some of the ways in which shame has given substance to places and relations I've yearned for, almost compulsively, and how it has fuelled a particular construction of 'freedom' I've practised for a long time, I suddenly feel able to really *see*. And I want to keep on seeing, really. I want to go back to the place of this shame-within and treat it as if it's an imaginary candle or a shimmering spark that can help me navigate the darkness that you and I both know there is no true recovery from. It's a part of us. Maybe that's why I love returning to Leo Bersani's writings so much, you know, because the rectum *is* a grave, after all (or a snake pit, haha). That is, I think the most compelling and challenging proposition Bersani brings up in his work is that *hey, maybe the sodomites are indeed damned*, but it is precisely in this living intimacy with damnation – with the violence of sex, the threat of death, the rejection by the gods – that our true, visionary powers lie. If only we can stop lying to ourselves about what's really going on in the dark.

If these lines have revealed a (prophetic) vision of WHITEHELL, then where does this leave us after having witnessed it? A BROWN PURGATORY? Purgatory is, after all, where those souls reside whose measure of good and bad deeds, words, and thoughts are equal. *The prophet is a place between worlds*, I recently read. The whole reason for Arda Viraf's journey I shared with you earlier is that he and the people around him had started to doubt their beliefs and practices. The opportunity to die before dying and see the world of souls is a *place* – not a message – to bring back to the world of bodies, in order to revive some kind of confidence. And maybe this place, this territory of in-betweenness, or as you put it, 'island positionality', is the world of liminal, uncanny, associative, and transformative images.

There shall be no Heaven for us, my dear. It's so boring there anyway.

Ashkan

PREM SAHIB
29 May 2022

Dear Ashkan,

I can't thank you enough for your letter. So much of what you mention I can relate to – the rage, the meltdown, the shame, the loneliness and the staying with it all. I don't want to stop seeing either. We've come back from death with a flame in hand, a tool to illuminate, guide, transform, even destroy if it wants, a Molotov!

I get what you're saying about the current rhetoric around care and empowerment. Trust me I want to heal too, but what is a wound without a scar? Maybe this refusal to forget, this going back to the place of trauma is a form of devotion? A non-gentrified position that tries to resist any sanitisation of struggle. By the way, I'm not championing some sort of conservatism, I'm all for burning things down! Nor am I suggesting that anyone stays with harm… no way. I guess what I'm trying to reckon with is the possibility of a more porous purgatory, a place that isn't concerned with the desire to 'belong' somewhere, but with the fight to exist. And like you say, a way to inhabit that in-betweenness so that 'freedoms' aren't just bestowed upon us, but come from us too. Maybe BROWN PURGATORY is where we move between worlds (or ruins of them) as they slowly crumble, the way that WHITEHELL is falling as we speak.

That Fire Over There, *like People Come & Go*, is a phrase that came to me in a semi-conscious state, of drifting in and out of sleep. It's an incomplete sentiment that occupies me as some sort of amnestic clue because those words happened to stick, retrieved from that place of souls you mention. I keep wondering what that fire is exactly; it feels like the source of something, the heat we all move to and from – is it the white heat of WHITEHELL, or simply the warmth of other bodies, 'community', family, home,

the sustenance of the hearth, that candle? I see traces of it when I stare at the cityscape like I did from the marshes during lockdown. From that proximity, the horizon looks like embers of a fire that are content on just fizzing away, maintaining the image of a given order of things, energy that's been harnessed but not properly birthed, millions of synaptic connections going on and off, sparks, labour, exhausted, awake, still wanting more, fun, now, please. That's how I looked back at London.

I was fed up of the world I was in – of white guys, fucking white guys and of transactions that excluded me, which if I'm honest I didn't even want or care for, but which remained as some sort of memory in flesh, an echo from past validation, a bad habit. I ought to offer that memory to the sky like they do in Delhi with the tradition of feeding black kites morsels of meat thrust into the air and expelled. I love thinking of that image of flesh flung upwards, travelling against gravity – dead meat forced into flight, only to be snapped up by the raptors that circle in sweeping cuts. Here, it's known as Sadaqah, a form of charity with nothing expected in return, a belief that this offering helps protect the family and keep evil at bay.

When I made *People Come & Go*, part of me was thinking out of rage and out of loss, and just like the men you describe visiting you in Athens, of people coming and going, of those who enter our lives and then leave. Be it family, friends, strangers, we move from one heat source to another, from intimacies, to care, to rage, sometimes getting burnt, sometimes seeking comfort. I'm aware this sounds a bit cynical and reductive but for me, there was also something liberating about this statement, like an acceptance of temporality and movement, perhaps even the implication of multiple states, so we're never just bound to the one here and now, to these relations only. Like some sort of revolving door, *People Come & Go* felt like there was a latent and never ending potential for life to continue, and to do so differently. But maybe it was also a grief mantra to protect myself... I don't know? Not just grief for the loss of my dad, but also my relationship to the spaces that represented that 'freedom to'.

The work itself is rooted in a gesture of repositioning the body that's so often at the centre of things, the body that some worlds are organised around in their entirety. I imagined casting

it back into its pit, locking it up, along with the consciousness that lay inert to people like me. That might sound mean-spirited, but I needed to talk about that anger somehow, about that burning rage, about that fire over there, which in turn became a direction – 'over there' became a new path, a point of deviation. I could sense something turning with this body of work, not quite an exorcism, as you say, but close.

For me, the installation was more than a fragment of a cruise club. It foresaw the enclosures we would soon retreat to just months later, that place we call home. Structurally, it was also a tunnel, a conduit, an artery with valves of corrugated steel that dared you closer to the heart of this matrix. When it was empty, I imagined it being a place of visions, like a cinema. And in that cinema of my mind, one of the many out-of-body recollections I have where I'm looking back at myself from elsewhere, is that incident in Berlin when I witnessed your heart stop. In the moment, mine did too. When I found you on the dancefloor the party was continuing around you – you were statuesque in WHITEHELL and we had to get you out of there. We didn't see what happened when the paramedics took you, but we tailed them to the hospital and waited for news that you were stable. I remember the plastic chairs in the waiting room sticking to the skin of my legs, as I sat there stunned and exhausted in my club wear, my eyes seeking comfort in the dirt that my body had accumulated from all those hours in the dark, marks which soon became triggers of anxiety and dread.

That night WHITEHELL showed itself to be more than a place or a condition, but a direction of travel that took no prisoners, an invisible white line into, as well as out of the space and beyond. Yes, I've been reading lots of Sara Ahmed, but as we discovered nothing gets in the way of this path – the party *must* go on. Ahmed describes whiteness as being so occupying, like a phone line that's always busy. I think it's also like a fold, designed to make you tumble down a steep axis until you're stuck at the bottom wondering how you even ended up there. Sometimes when I look around me and I'm feeling cynical, the disorientation is palpable. There are moments when I feel transported to a dead-end, or a cul-de-sac and I'm at the bottom of the bag; it could be an art opening, a dinner, in a room full of people, not just certain clubs,

it's a texture of the world I'm in. All this weight, the history of my body, can feel inescapable. It fuels an anger and frustration in me that aligns with shame because I am forced to recognise the way that whiteness has shaped the course of my life. But re-orientation is of course possible. Is this also the revival of confidence you mean to invoke with Arda Viraf's journey? Although that memory from Berlin haunts me, I can reassure you *People Come & Go* wasn't about you directly! I think we were all on a mission that summer and what happened to you, to us, was a reality check about the supposed freedoms we practiced. I mean, is there really such a thing as a safe space?

Some forms of detachment can be a way of looking back, of leaving the body, to glide. To clarify, I wasn't trying to shame anyone who is passed out, it's a familiar image in certain places like you say. There's always someone asleep in a cubicle or snoring in the darkroom. I've been there myself, rolling up a towel to use as a pillow to avoid having to get the night bus back to Southall, trying to sleep with the soundtrack of bad house music and fucking. Also, there are people who practically live in saunas – the entry can be cheaper than a hostel in London these days. So being passed out is also being elsewhere, in two places at once, that place of in-betweens. But this estrangement from the body is not all vision seeking, altered states, or exhaustion. It can be more dissociative, a way to divorce ourselves from the world we're in. I hope I'm not coming across as moralistic, but I want to distinguish that place of visions from that place of nightmares. It occurred to me that this image we're discussing has a relationship to shame because it's seldom outward facing; it's something that is shielded, something to be forgotten or overlooked. Its audience keeps it there – we become complicit in what happens in the dark, that darkness you so aptly describe there being no true recovery from.

I can recall many bodies carried over the shoulders of security, through the edges of packed dance floors, or poured into cubicles that look like hutches or pens, where flimsy walls provide somewhere to leave the body. Can moving an image seen only by a few or recounted in our mind's eye, be a way to dissolve shame somehow, to dislodge the power of its framing and concealment? It's not dissimilar to how I think about sculpture, as the act of

carrying something with an emotional weight from one place to another – finding somewhere to dump it, and then having to deal with the consequence of that placement. A practice of carrying, moving, storing, leaving.

I also thought of shame as something that happened elsewhere, Ashkan. And for me, maybe it's not actually the same as that image of a vacated body I was initially interested in – a dejected and abandoned form. But I have vacated other places, I have distanced myself, left, run from, or denied my own site of pain. How do we then re-embody the world when we come back from these deaths?

I really appreciate you sharing what you have about your relationship with your father. Mine also had its challenges at times. There were a few years when we didn't speak, especially around my teenage years when I began dressing differently and standing out in Southall, wearing makeup and dyeing my hair. So I understand the trigger you're describing, how one word, siphoned through generations of history and meaning, can be summoned through an inflection or tone and cut so deeply, bringing all this and more to the surface in an instance. I found the equivalent in silence too, or the 'silent treatment' and its invisiblising effect. But amidst these complications he also told me something beautiful – that we have grown up together.

I wish I could go into some things more. Like the stories my dad shared with me before he passed away, things about his own biography that allowed me to better understand what shaped him. But shame and pain go so hand in hand, that perhaps some things are better left buried after all.

He once told me about some of his own brushes with death, like when he fell through scaffolding whilst working on a building site, or on a trip to India when the driver fell asleep at the wheel, or how as a child, he accidentally overdosed on medication and saw a guru appear on a horse. I became so obsessed with these near death encounters, with things I learnt about my parents' lives before I even had a body. To me these were clues or slippages that humanised them and challenged the rigidity of their social role; that object way of seeing them, which was also a distancing device, keeping our stories apart. There are physical spaces that intrigue me too, because they hold some of our shared

biographies. For instance, my mum told me about the time she was homeless and slept rough on a bench in Walpole Park in Ealing, a time that I imagine was one of significance for her. This was the same place I used to go to in my teens to meet strangers. It was the same park my sister used the ouija board in.

There is so much more I want to talk with you about! Like jinn, which you touched on briefly, and which I know we've both been drawn to thinking through. Also how you've been using fire and burning in your work.

It's so good to be able to have this conversation with you babe.

Thank you again.
Prem

ASHKAN SEPAHVAND
20 June 2022

Dear Prem,

Responding to you feels different this time, less of an urgent swelling of associations and more like a scattered sifting, trying to piece together some momentum. Yesterday was Pride here. Such a funny concept in 2022, I think. I had no plans to go out or join in on the festivities, though somehow Pride managed to come to me. The events were relatively nearby to where I live and so, all afternoon, the peace and quiet that characterises my island abode was disturbed by echoes escaping from the main stage: off-tune singing, cheesy pop music covers, and townie MCs trying to hype up the cheering, suburban crowds. I exchanged a few messages on the apps with locals inquiring if I was going to be around. I could have simply said 'no', but I found myself responding with a killjoy edge (speaking of Sara Ahmed!): 'I don't think it's personally special or politically interesting to desire to sleep with the same sex.' Overshare, geez. Of course, I know it's much more intersectional than that and admittedly, I was trying to be provocative. But part of me does wonder, what's the point of sexual identity these days?

I guess following up on my last letter, the theme of shame feels like a binary counterweight to that of pride, but that's not what I'm trying to get at here. Indeed, much like you, I've been questioning for some time now what constitutes contemporary notions of freedom. How is this freedom to be experienced? What is the language for acting and articulating such freedom? Is it just as simple as being able to do and get what you want? That keeps it so individualistic. It is easier, we are told, to keep freedom located in the individual, as a consumer's private choice or bold self-affirmation. So what about the collective? Every time I hear this word, it feels so cringe to me. I associate it with the vagueness of corporate, institutional jargons that superficially invoke community or participation as reified interest groups. For me, it all feels co-opted, forced, and

disingenuous. How to complicate what is meant by freedom?

Let me get at this from another angle. If I remember my Sara Ahmed correctly, she once wrote 'our happiness is a platform and a horizon.' I had used this quote in one of my pieces from what I call my 'club writing' period. Not without a certain ambivalence, mind you. During that time, I guess between 2013–2018 or so, both you and I were voraciously exploring the possibilities and limitations of freedom on the dance floor, in the night club, at the after hours, through countless sexual encounters, within the folds of labyrinthine undergrounds, and along the unequal surfaces of desiring bodies. We were tracing something. Was it a sense for what may have been possible? It all felt very special, the excess and the exaggeration, the spontaneity and improvisation, like we had discovered a coveted treasure.

At the same time, I feel we both sensed a certain malaise, an uncanny suspicion that 'here', however much it seems to be a 'somewhere', might be a 'nowhere'. The constant flight of restless desire, unimpeded and without bounds, leads to perversion: what the Other wants can't be allowed to matter. This could be why in all the texts I wrote through the prism of a party, I found myself repeatedly invoking ruins. It was almost as if in the energetic storm of heat, smoke, light, drive, and passion, an after-image of a banal nothingness would faintly flicker from time to time, hard to see and even harder to hold on to. I tried to ignore this and just enjoy myself, and in repressing this vision I found myself obsessing over the catastrophic. Maybe one way to avoid an uneventful nothingness is to embrace an apocalyptic sublime?

My writing oscillated. On the one hand, there were images of nostalgic alternatives that could restore and refresh the ruinous. I wrote about 'the faggots and their friends' practising death-rituals and transmitting traditions of care in the face of spreading dis-ease. On the other hand, there were accelerated fantasies that intensified ruination to the point of cynical absurdity. I wrote about TULSASLUT adrift in WHITEHELL, the hellish world of the men, and about those sent to the identity-territories that were not-so-secret extermination camps. Neither were convincing or sustainable enough for my imagination to follow through with, and so, my club writing period ended rather anti-climactically, without a last word, just as we entered the enclosures, as you call them, of lockdown.

In the meantime, I've gone back, slowly, and not without anguish, to face this nothingness. It certainly helped that the ecstatic horizons of

our once-understood freedom seemed to have since withdrawn, been suspended, or gone into hiding. Over the past few years, an existential quietness embraced us all, silently devastating. It was all too easy to finally see the ruin. Unexpectedly, however, something else caught my attention. In the aftermath, once the parties were over, the bodies dispersed, the sex on hold, the desires interrupted, what remained was banality. The day-to-day of living on, its fragility, and the tenuous, survivant grasp on life itself.

It was here, confronted with this unavoidable sense of dailiness, that I realised banality was at the core of what had fuelled my defensive repression. As if something all along was trying to tell me: what if this isn't special, what if you aren't unique, what if you are just like everyone else? This sounds defeatist, or, even worse, toying with apolitical relativism. But going deeper into the disturbance of the banal has revealed for me a something far more complex. Banality is terrifying because it brings me back to life as the 'nothing which is something'. Banality is irritating because it forces me to cast off the reflections, projections, fantasies, and significations of identity, leaving behind only the fleshly, material, unspeakable Real. Banality is confounding because it destabilises the motivation behind the stories I tell about myself and others, turning the political inside out and towards a serious, challenging unknown. And banality is disappointing because it strips both individuals and collectives of exception, leaving no room for spectacle, performance, or consumption. Is banality, then, a sort of not-so-secret commons, a true levelling hiding in plain sight? Or is banality a trickster, causing me to contradict myself as I struggle to shake off the liberal addiction to novelty?

Does this touch upon some of the thoughts you are describing with *People Come & Go*? That beyond the highs and lows, the joy and the rage, there is a life, bare, beating, and beautifully banal? Or how in *Cul-de-Sac*, the altered state of the mind's eye you lend us access to, while dissociating in the echo chamber of toilet stall chatter and darkroom nonsense, transports us ominously back to the drab, semi-detached suburbs that unspectacularly signify home? Is this what you mean about detachment and placement? You use these words separately in your letter, but I associate them with each other in my reading, and put them together with your description of 're-positioning the body'. Is detaching-from a kind of disavowal, disconnect, or disturbance of the self-authorised exceptional? Is it like the 'confronting nothingness' I have tried to describe? Does detachment create the conditions for courage that can enable transposition, translation, or, as you say, a carrying over? And

what are the consequences of having to deal with this re-placement? I think it's political, but in a de-dramatised way. Suddenly, an object, body, or environment is no longer able to draw on the powers of fantasy and fetish found in its usual place. The drama is gone. Out of place, it starts to feel annoyingly ordinary. No longer hiding behind over-signification, the displaced material detaches from the meaning it's supposed to have. Is that when materials can begin to speak a language that doesn't evade? And what if what they have to say is nothing special and as such, deeply meaningful?

I want to go back to the striking image of 'that fire' you describe – the vision you had of London burning on the horizon. I think it's so interesting that right after this you write about your desire to make a Sadaqah offering to the birds. The association I see here is one of sacrifice, which is how I've been thinking through fire as of late. I think I've told you how at the start of last year I started to burn my writing. More specifically, I decided that the only way I could write the story I was working on was to burn each page after writing it, with no record of the content left behind. You see, I was stuck in that 'apocalyptic sublime' I mentioned earlier, believing I wanted to write about the men and their ruins. I had started and stopped numerous times; I was, quite literally, captured by WHITEHELL. The new year came and perhaps it was the darkness and cold of mid-winter or some pent-up need for ritual and release when this pyroclastic urge overtook me. I learned so much through the burning. I learned how to let go of a story that wasn't mine anymore. I couldn't write about the men because I had lost my desire towards them. I learned that his story was not my story. I learned how to allow for transformation by believing in the mystery of sacrifice. That by offering something into the unknown, a space is made for something unknowable to return. There's a contemporary misunderstanding of sacrifice as something ruthless or selfless, a giving up of something completely, or, even worse, a senseless destruction. But sacrifice is a relation of gift, and the gift must keep on moving, changing. It's the charity you describe, that returns its protection mysteriously and in unexpected forms.

I learned that in ancient Indo-Iranian spiritual practices, fire is the most sacred element, the focal point for all ritual. Sacrifice is conceptualised as cosmic digestion. The offering is consumed, transformed, and its remnants expelled. The fire mediates the sacral gift, sending a part of it into the air as smoke, distributing a second part to the earth and waters as ash, and keeping a third part for itself, energetic,

invisible. Not only was I burning off a desire and an imagination that no longer served me (had it ever?), I was also learning to pay attention to how the other of imagination materialised as smoke, smell, heat, and ash. I learned that nothing is destroyed, there is no end, it's not the end of the world, there is only incessant transformation. And that's scary because it's an inhuman process that can't be controlled or fully understood. It's also banal when all you have as a proof or promise is ashes. I learned that my story is elsewhere, that my writing takes place in this aftermath of material. Can I write, draw, imagine with ash? Can I practice in it? Where would that take me, what could it do?

I'm glad you brought up the jinn. During my initial burning exercises, I was thinking deeply about these creatures of fire rooted in Islamic imaginary as figures of elemental transmission. I'm not so concerned with them directly anymore, but your reminder is important. What the fire, ashes, and jinn showed me was the urgency of claiming one's right to imagination. I realised that for so long my imagination was held in the abysmal fold you describe, that supposedly natural and universal space of whiteness. And even more specifically, in white homosexuality, with its fables of freedom and oppression. I couldn't see how impoverished I had chosen to remain in this, self-blinded towards all the traditions of imagination I carried within my ancestral memory. I occupied myself with white myth, keeping busy with faeries and cyborgs, revolution and the Anthropocene, testo-junkies and drag races. I forgot to remember that something much older than me once knew other strange and wondrous beings. Jinn, div, luti, pari, pahlevan, and many more names I do not yet remember. It's become clear to me how vital it is to insist on this other of imagination (as opposed to imagination of the other), which also means to practice it. For me, this means unlearning the stories that once attracted me, and re-encountering the object of my desire. Especially for us brown sisters, I see no reason to continue desiring 'the fabulous' as it's fantasised by whiteness, or to draw one's creative references and spiritual values from its space of enfolded homogeneity.

I want to end this letter by looping back, full circle, to where I began in my first reply: with a memory of the father's speech activated through listening. A friend of mine, an Iranian curator, recently recommended I listen to a series of lectures uploaded onto YouTube by the late Shahrokh Meskoob. He was a writer, translator, and literary scholar who worked extensively to develop a critical apparatus for Iranian myth. The lectures are just audio recordings from a series of private seminars Meskoob held

in his home in Tehran in the early 2000s, discussing the *Shahnameh*, or, 'Book of Kings', an epic poem written by Ferdowsi in the eleventh century. They're so fascinating to listen to, if only for his gentle voice and kind, passionate nature. I am reminded of my father again but this time I feel no shame. I remember his recitations and this time I feel love and pride.

Meskoob's lectures are not so much structured analysis as endless excursus. He wanders as he speaks, often leaving the centre and spending significant time on the margins. There, in the resonant in-betweenness of classical text and contemporary experience, Meskoob offers associative reflections on the world, time, history, sovereignty, and speech. His discourse is not deformed by neoliberal knowledge economies (there are other challenges in his context), so he's not forced to make clear, catchy, accessible points. Instead, it feels like a mirror-hall of aphorisms and wisdoms, a story about a story about a story. It's been nourishing to move along with his words and in doing so, become intimate with the shape of his thought. There are many beautiful things I have heard while listening to these recordings, but one line truly takes my breath away and I'd like to share it with you. Of course, it's my translation: 'Free is the one who is able to carry their social desire as a message of truth.'

How much imagination is needed against today's unfreedoms that pose as freedom!

Yours,
Ashkan

PREM SAHIB
3 August 2022

Dear Ashkan,

It seems that we were experiencing parallel Prides. While awaiting your response I was in Barcelona for a music festival and decided to go to Sitges for a few days after, not knowing it was Pride there. The town was so full, especially on the main strip of gay bars, that I was stuck at times in what felt like an imposed paralysis, a kind of forced spectatorship of the lives of everyone around me. Before deciding to delete, I started this letter differently – moaning basically about how some gay culture aped the worst of straight culture, about the competitiveness and objectification that became so tiring to be around, and about how those scripts of individual freedoms left me feeling disconnected. Can you tell I was having a comedown?

It's strange to think of 'deaths' as we have been, because one of the places I visited while on this trip was Cala de l'Home Mort, literally translating to bay of the dead man. This nudist beach is situated in a spot that requires walking alongside a railway track where high speed trains pass by rainbow graffiti that demarcates the 'GAY ZONE'. As far as I know, the main cruising spot is usually amongst the pines on the opposite side of the tracks, but on this visit it seemed more active towards a remote part of the beach. If you can swim well enough, you can access that area more easily; otherwise venturing to this spot involves climbing over rocks and through mini caves. There was nothing graceful about how I got there, with blisters on my feet. I stumbled awkwardly over sharp boulders, wearing cheap flip flops that were falling apart, and which I'm sure made me look even more ill-equipped for this terrain.

Once I'd made it to the other side, there was a dark cave packed with about fifteen guys all getting off in groups. The first

thing I saw was their white legs glowing against the surrounding rock which upheld an impeding boulder hovering above their heads — the scene looked like a naked version of my sculpture *Beneficiary*, which was exhibited in the final part of *Descent*. This work is comprised of eight plaster cast legs, each in an identical uniform of white socks and trainers, positioned behind a stud-wall in the gallery and softly illuminated to look like they are huddled around the white light of a mobile phone. It had a lurking presence that suggested an expanded body or tribal alliance. I found myself thinking about these eight legs as spider-like. And just as a web is a structure designed by the spider for the spider, I wondered whether this beneficial form, that is so integral to its survival, might also be a trap for more than just its prey? Could those intricate, near invisible lines that are spun with its body at the core also be what hold it in place and affirm its centrality and comfort?

I remember thinking about the lengths that people go to find this space, while also being sympathetic to why they might. Don't get me wrong, it was super beautiful here. It was private and isolated from the outside world. The iron in the rock was a deep orange stain, and on the surface, it was idyllic. But beyond the train dodging, the risky landscape and the aggressive waves that repeatedly beat the coastline, retreating periodically so I could advance in my journey, there was also an underlying and subdued violence; I don't know if it was a combination of the location, its name, my state of mind, or hyperawareness of feeling like an intruder. Perhaps it was also my familiarity with the mechanics of this situation that made it violently predictable. It felt emotionless, dead – I could sense a desire paradigm at play, a kind of psychic filtering of bodies deciding not only who would arrive at this point, but also who would warrant an interaction.

Being recognised as a person in this dynamic felt contingent on the permission of a white imaginary to bring *some* bodies into its fold on the condition that they align with or perform to its image. For all the tropes of gay paradise this space might have elicited, I wasn't feeling it. I hadn't died and gone to heaven. This might have been one of those moments where I began to see everything through a racialised lens, where I read the disapproving looks in some people's eyes as a reaction to my presence ruining their fantasy. But maybe that was *my* power in this situation, the

power to destroy the reality produced just by being there, to put an end to it. Everything here was a reminder of death.

I know your letter was supposed to be our last correspondence here, but I felt like I needed to reply. I wanted to tell you about a book I began reading, ominously, on this very beach of the dead man. Amira Mittermaier's, *Dreams That Matter: Egyptian Landscapes of the Imagination*, is an anthropological text centred around research on 'divinely inspired dreams' in Cairo around 2003/4, a time characterised by the author as particularly 'undreamy'; as some of her interlocutors explain, 'we're living a nightmare' – a commentary on the economic and political crisis the country was experiencing.

I really like how dreaming is explored by Mittermaier – more expansively than just the 'inward projection' of an individual subject, or as escapism. In a way that might be conceptualised by Amerindian dream theories, describing a kind of 'tuning in' to the world, here dreams have the capacity to *be* a form of encounter. In this sense, a much broader conception of 'community' seems possible, one that might be wrested from the grips of the neoliberal framing you speak of even: always reverting back to the individual and never that distant from corporate interests. I'm still reading the book, but I got excited about this suggestion of an 'embeddedness in larger orders' and what Foucault describes in his earlier writing as a means of 'exploding the subject's boundedness'.

In outlining her anthropology of dreams, Mittermaier also shows the historic suspicion that has existed within Western rationalist traditions and philosophy when it comes to the imagination. An anxiety around distinguishing waking life from that of dreams and visions resulted in a mistrust of the senses – a problem that was apparently remedied through the Cartesian invention of 'reason', but which has unsurprisingly helped maintain ideas of infantilised, uncivilised subjects, incapable of making that distinction themselves, thus discrediting certain types of knowledge.

This made me think of being captured by WHITEHELL – and of the need to find routes out of the carceral system of prescribed freedoms, to reclaim our imagination away from the 'self-authorised exceptional' you describe, moving instead towards more capacious forms. And with this, I keep thinking back to

what you said about how 'what the Other wants can't be made to matter'. Mittermaier also questions the idea of the Other, by asking what is excluded from this category, in other words, what about the 'other Other'?

> Is the Other to be converted into sameness, to be tolerated, or to be engaged with to the extent that one risks one's own position in the encounter?
>
> Are Others that count only one's neighbours, or are they also strangers? Are they only the living or also the dead? Are they necessarily human or could they also be spirits, ghosts, or dreams? My interlocutors' narratives gesture not only beyond the boundaries of the autonomous individual subject but also beyond those of the visible social world.*

I have a memory from when I was younger, of a family drama concerning a mysterious package found on the side of our house by my mum and auntie while they were cleaning one day. It was a small bundle of tissue paper that had been sewn up and wrapped in burgundy thread. Inside were matchsticks, each inscribed with the initial of every family member in red pen – apparently, it was a curse. We soon began speculating about who might have targeted the family in this way and the appropriate advice was quickly sought to counter the hex. It seemed that diffusing its power would first involve disposing of the package in running water: it left our house and entered a tributary of the River Brent by the viaduct near Ealing hospital. The next few years would be characterised by a run of bad luck. It is, of course, completely plausible that the 'curse' became a way to account for inevitable misfortune. But I have to admit, there were a few freaky happenings, like when my parents woke up in the dead of night to find maggots crawling up the entire façade of the house. I didn't see this myself but I was there, asleep in my room.

Although conversations around this event are now generally shrugged off and details disputed, it did stay with me growing up. In my mind, perhaps it even became a way of bonding over a sense of shared damnation – forging equivalence with my own, queer child's intuitive understanding of a hostile world, mediated through the headlines of the time or comments I would overhear

and savour. Maybe this event helped affirm feelings of being bad, punished or hated? But why I am telling you this...? Because on the flip side, I think it made me more acutely aware of the apotropaic strategies required to overcome the invisible forces that supposedly shaped our life – of ways to re-think power dynamics with the power at hand.

In his book *Jinneology: Time, Islam & Ecological Thought in the Medieval Ruins of Delhi*, Anand Vivek Taneja describes jinns as having the capacity to supersede human institutions of memory and time. Jinneology consists of connecting otherwise disparate modes of knowledge through non-linear and non-genealogical transmission. Thus, at Firoz Shah Kotla, the ruin described in the book, communication with jinns is used to reimagine political frameworks and bypass the realities of life in a postcolonial state. Visitors from various religious backgrounds venture into the dark subterranean passages of this Mughal monument where the jinn saints are said to reside and leave offerings and letters that petition them for help. Interestingly, the letters mimic the bureaucracy of the Indian state, sometimes even including job applications or photos attached to documents that are often photocopied multiple times and left in the niches and alcoves. In this sense, they become a form of correspondence that both acknowledges certain structures while simultaneously disregarding them. I was drawn to thinking about jinn because of their relationship to 'deep time' and to events and knowledge that exceed the biographical limits of us humans. Although I have no religious affiliation towards these figures, they intrigue me as shapeshifting, interstitial witnesses that move between different temporalities, made, as you pointed out, of smokeless fire.

I am not suggesting we can imagine away social constructs or pretend the structures we inhabit don't exist, but just as we might readjust our focus towards a reflection in a surface, allowing our eye to stray beyond the seemingly apparent, maybe there is something to be found amidst that brutal place of the banal you so movingly describe, like a way out? It goes to the heart of what I felt *People Come & Go* was in some ways – an attempt at iconoclasm. When I began transposing the cruise club into the gallery, I became more aware of the discrepancies that occurred through my act of mimicry. Just like the letters to the jinn saints,

which might resemble documents you'd expect to be sent to a government department, in replicating while redirecting, my copy of the club would mean prising away certain attachments to the body and its environment, looking elsewhere to reconfigure these. In doing so, I was also trying to implant my own trajectory. Over a coffee, a friend who worked at the club would tell me the exact playlist that was often on repeat during his shifts, or the exact bleach that was used to mop the floors at the end of each day, details I chose to omit in the end, so the body of my performer would instead be experienced in proximity to a new soundtrack – the less spectacular sound of the gallery staff tapping away at their keyboards from an indecipherable distance, writing work emails. So yes, I do see this act of moving something or 'dumping' it, as I may have clumsily described, as being political, because I was trying to reproduce this image with a crack that might destabilise it. I was trying to examine it away from the supposed power it had, both in my imagination and the spaces I shared with it. Isolated, it became flimsy, haunting the corridor like a ghost, relegated to the past.

Drifting towards another polluted (and disputed) memory, I remember being told that one of my uncles and I would bring the family good fortune. As a child I'm sure this brought me some degree of comfort along with an inflated ego, but looking back I can see I was the likely recipient of patriarchal favour, delivered through the whisper of a person advising the family on protection rituals – burning chillies daily for a week, if I remember correctly. By chance, the same uncle in question (not to be confused with the uncle whose archive exists in this book) was only a few weeks ago driving me around Southall in his old postal van, a two-seater vehicle perfect for both of us 'lucky ones', while he generously narrated his own accounts of the same streets I was so (un)familiar with. This time the luck was all mine, as he attested claim to historical events I was just arriving at, pointing out alleyways that would connect various parts of Southall and which allowed people to 'duck' from the police when necessary. We drove past a soon-to-be housing development advertised on glossy hoardings with bland interiors, accompanying the arrival of Crossrail to the area. This particular development, which looks like more unaffordable housing, is on the site of the old gas works – a

building that once punctuated the view from my window at home like a local landmark. Since the development began, the soil on this site has been found to contain benzene, naphthalene, asbestos and cyanide. Local residents have complained of a 'petrol like odour' in the air, and some have even experienced breathing difficulties and an 'internal burning sensation'. In one article, someone described feeling like their neighbourhood was trying to kill them.

In Old Southall, my uncle showed me the railings where an eighteen-year-old Gurdip Singh Chaggar was murdered in 1976, stabbed to death unarmed in a racist attack. It's been said that a pool of blood was left on the pavement, and when Suresh Grover, then passer-by now anti-racist campaigner, asked a police officer about who had died, he was told 'it was just an Asian'. This death would lead to the formation of the Southall Youth Movement (SYM). We drove past the building where they used to meet, which was once an old youth centre. Back on the other side of The Broadway, he pointed out the unassuming corner of a residential street where Blair Peach was struck in the head. We got out of the van and together inspected the now boarded up Hambrough Tavern. It used to be Mary's Free House before this. I noticed piles of ash and burnt debris that looked like anachronistic offerings to what had happened here in 1981, the year before I was born. 'Oh it became a fire, because what happened was, the police, the riot police, SPG, they were protecting these guys who were at the back. They were throwing stones, bricks, whatever at us', he told me. That fire was borne out of a refusal. It occupies a slightly lesser place in the history of resistance movements of the area, I suppose because it strays from the respectability associated with other forms of protest. There was something freeing though, hearing of those who helped themselves to drinks behind the bar or had a go on the gambling machine amidst the place burning to the ground, maybe even looted a present for their mum when shop windows were smashed in. There were no letters written this time, but I can still imagine the smell of smoke in the air and the glittering carcass of the venue as dawn emerged. Southall was a different place back then I'm told. You had to walk around in groups to be safe if you were brown, or in my parents' case, risk attracting the wrong attention just by being seen together. My uncle asks me, 'Was it worth your while coming here for all this Prem?'

In recent years, I have returned more often than I used to. Last summer I attended a ceremony outside Southall Town Hall, where three plaques were being installed four decades later, to mark some of these histories. The original ones had been stolen. Apparently they'd been 'cut off' the building. This time they were placed higher up and out of reach, with the empty holes left puncturing the brickwork beneath. This is the town hall where the National Front had their meeting on 23 April 1979, sparking demonstrations that would later become known as 'the Southall Riots'. I heard Celia Stubbs, the partner of Blair Peach, speak about how she was spied on by the police for more than two decades after his death, as they monitored her efforts to bring him justice. I witnessed members of Gurdip Singh Chaggar's family address the small crowd that stood listening, where hundreds of people once took to the streets.

I live amongst a rhapsody of images, encounters, snippets, fragments, history, whatever you want to call it. On these same streets, I've been spat on and punched in the face, for different reasons. I've been cheered all the way down The Broadway too, coming back from a night out in broad daylight with orange hair, coincidentally on Vaisakhi.

When I told you about 'that fire over there', which has now become the title of this collection of material, I was on a piece of land no bigger than this room. I felt like we were sat opposite each other indoors but it was actually outside, like a small clearing in a forest. I could see an incredible cloud forming behind you, a cirrocumulus I think. The sky was an orangey purple and I was trying to distract myself from telling you that I was uncomfortable about being recorded. I didn't want my voice to be fixed in any way. I saw a bird appear behind you, a kingfisher, but I could only make out its silhouette. When I walked towards it, I quickly realised I was on the edge of a cliff so I crouched down towards the ground, slowly guiding myself back towards a centre.

You know that fire over there, it started a long time ago. It was just a spark at first but then eventually people tried to tame it.

Prem

*Amira Mittermaier, *Dreams That Matter: Egyptian Landscapes of the Imagination*, University of California Press, 2011, p. 5.

06.07.21
Intense gushing from my knee, blood everywhere.
I think Xavi was there trying to help me.

04.10.20
There was an owl in my dream. I think
it was white. It may also have been an
eagle. I was photographing it. I feel like
there was some familiarity of being at
home in Southall. I looked out of the
window upstairs and saw the extent
of the back garden, which looked like
it was being prepared to grow crops. I
think Phillida was there, and mum too.

02.10.20, 06:02
I was being provocative and silly and
chatting about sex while on holiday. I
didn't realise that there was a kid within
earshot and that his guardians, who I think
were people we vaguely knew, also heard.
Xavi said he thought they might be pissed
off with me, so I again (provocatively) said
'well I'll just go and speak to them and ask
what I said, cos I can't remember'.

They were having dinner and I went over
to politely say I was told I was speaking
too loudly and may have said something
inappropriate. I felt immediately bad that I
wasn't being conscious of my surroundings
when I had been talking to Xavi. One of the
guys accepted my apology and didn't want
to make too much fuss, but the other guy
was really fuming and told me that I was
discussing sex and it was disgusting to say
what I did in public. I apologised profusely
to them all. I genuinely didn't even
remember having said something rude.

Prior to this we were with George
and Caro and their new baby.
We were having a good time.

Cut to me discovering two dolls
that I think belonged to people in
the group we were with. I noticed
that one was broken or had
been damaged and I can't really
remember the rest but it felt like I
was also a nanny to Boris Johnson.

Travis Alabanza had been there
earlier. I felt as though they didn't
like me, and I was trying to make
them like me.

05.6.22, 01:31
I was walking down the street with Pouji.
I didn't realise I was a bit drunk and I
was swearing about Boris Johnson or the
government. It was quite dark and it felt
like I was coming home to Southall from
a night out. I noticed that all the houses
on the street were moving in the wind like
they were cloth facades. Even though it felt
like home, it wasn't exactly the same place.
When I entered mum was asleep on the
sofa. I was trying to go upstairs quietly.

Morning of 27.09.20
I woke up almost in tears. I was at home in Southall and upstairs in the house. I had entered mum and dad's room. They were in bed giggling and sounded joyful. I remember feeling happy for their security. But then, it was like the scene cut to dad's death. The transition was so abrupt I woke up shocked and upset. In an instant, I went from an image of contentedness, to one of dad in his coffin.

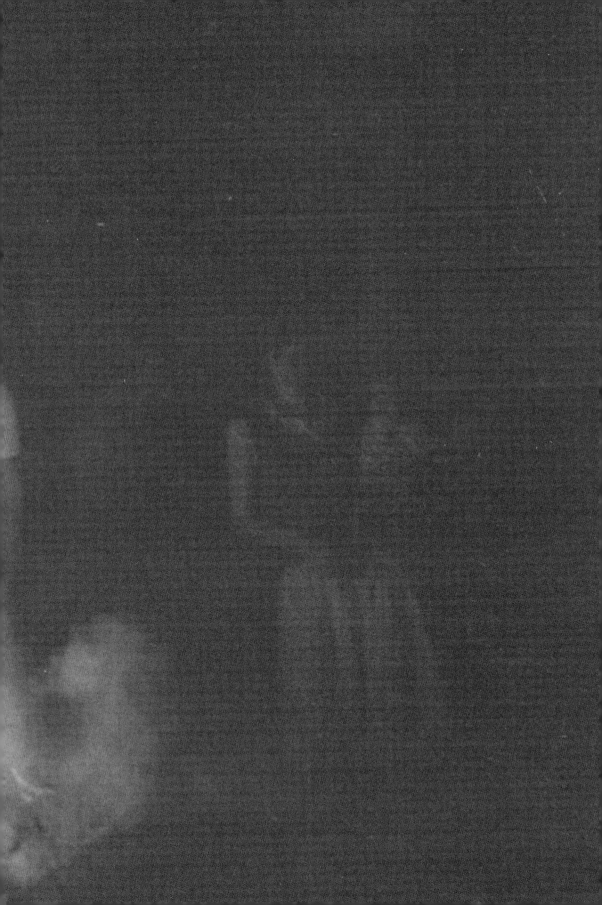

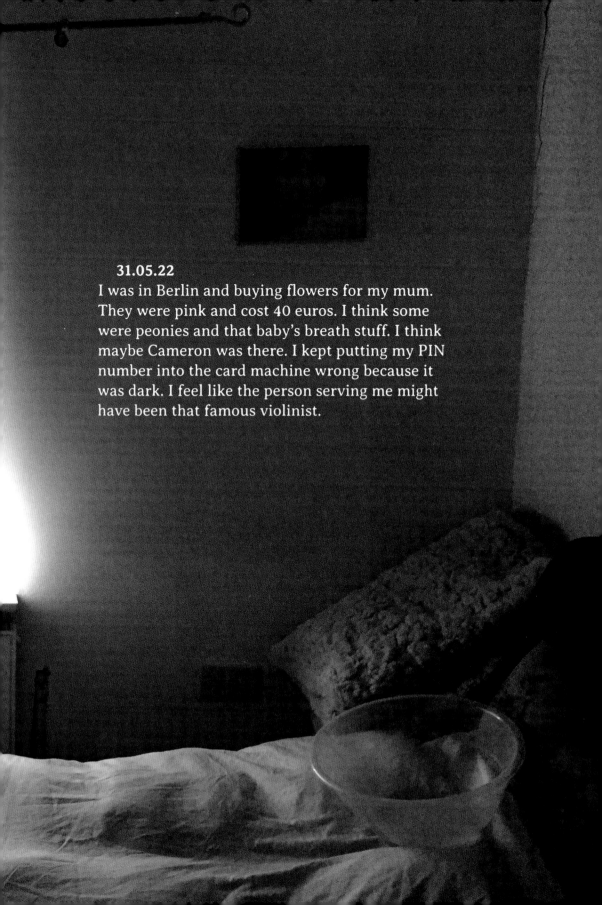

31.05.22
I was in Berlin and buying flowers for my mum.
They were pink and cost 40 euros. I think some
were peonies and that baby's breath stuff. I think
maybe Cameron was there. I kept putting my PIN
number into the card machine wrong because it
was dark. I feel like the person serving me might
have been that famous violinist.

28.09.20, approx 07:00
I feel like this question was put forth by Anika from something she was reading, but it also interested Ramone. It was something along the lines of 'are we alone as beings in an illusionary surrounding or do we have a community around us that actually exists?' Mum had brought some new things, including a coffee machine, and was making me a nice coffee. I was in the back room upstairs and it felt like I was visiting. Anika was downstairs with the kids and mum and they were talking about the price of some toys.

Before all this, I was underground in some tunnels and there were creatures such as rats, many of them pure white or possibly albino, as well as beautiful insects with hard, complex, structured shells whose design was inspiring me somehow.

21:56

Thu 9 Sep

I have a memory of being half alseep in the box room when you came home that morning. I heard you run up the stairs and go into mum and dad's room. I couldn't make out the conversation exactly, but do you think that was when you told them what happened in the park?

21:42

Fri 10 Sep

I think that's right but I can't fully recall... I think my friends stayed the night because I remember us all sleeping in the same bed because we were scared... then first thing I went to tell mum and dad... who weren't very impressed. I think dad was a little upset, maybe I didn't take much tact and it was his dad that came through (apparently)

07:28

We had made the ouija board the night before in my room on yellow A2 cardboard... all my friends had come over that evening and we did

22:17

last seen today at 20:00

Tue 14 Sep

We had made the ouija board the night before in my room on yellow A2 cardboard... all my friends had come over that evening...

So it was night-time when you went to Walpole Park? Do you remember where in the park you were? We hadn't met before. What did he say? 09:11

Yeah, night-time... I can't remember exactly where but they've changed it since – there was a picnic table near the stream – we did it on that 09:17

In terms of
I've forgotten a lot but what I do remember: the overall sentiment was one of displeasure with the family – said he wasn't happy 09:18

Do you remember if he said anything or was it more YES or NO type responses? 09:19

I mentioned because that's what came to mind and he said he

22:56

last seen today at 20:00

We had made the ouija board the night before in my room on yellow A2 cardboard... all my friends had come over that evening...

Which room are you referring to btw? At our house? 17:22

Hey! No of course not happy to help xxx

Thank you xx 17:22

What was recently dad's room – upstairs back room 17:23

That's where I'm texting you from now – lol 17:23

17:23

And how come you went to Walpole park? Did you guys used to hang out there? 17:24

Yeah, for a bit, Ealing had a few bars/pubs that weren't too strict serving us and as there was the night bus it was a good option. We were only

22:57

last seen today at 20:00

And how come you went to Walpole park? Did you guys used to hang out there?
17:24

Yeah, for a bit, Ealing had a few bars/ pubs that weren't too strict serving us and as there was the night bus it was a good option. We were only first year sixth form
17:25

Do you remember what time it was?
17:25

Time of day? Evening, probably 8ish
17:26

so was the park open or closed?
17:26

Was dark though and the park was closed, we climbed over the gate
17:26

how did you see what the board was saying?
17:26

I can't remember tbh... no smart phones in those days lol
17:27

22:13

last seen today at 20:00

Only one of our friends could drive at that point so about 8 of us piled into his tiny car and we went to Walpole park. We had all agreed no drugs and no alcohol that night – it was a really serious thing for us and even though we had some doubters in the group, one of my friends had done it lots before and had seen her family do it so most of us were expecting something

07:31

17:39 17:39

+2

17:39

6.jpg

7.2 MB .jpg 17:39

21:56

last seen today at 20:00

How does it work in terms of communication or spelling out words on the board? Is there something that points to different letters?
10:24

You have your fingers on an upside-down glass and the glass moves to spell out words – it's alphabet all around the board – 0–10 numbers across the board and then hello and goodbye; yes and no... at least that's how we made it on like A2 card
10:26

Get the creeps just thinking about it... was yellow
10:26

sorry... 10:26

thanks for sharing with me though
10:26

21:46

Fri 31 Dec

I remember we asked where he
was and he kept repeating the
same word that we didn't under-
stand. Later we asked my friend's
grandmother and she translated it
as 'ashes' in Gujarati 17:31

Mon 10 Jan

Do you remember what the word
in Gujarati was? Did he spell his
name? How did you know it was
him? 10:18

I've been really trying to think and
it's on the tip of my tongue but I
can't remember... I think asked in
the term she used to address
him in 10:21

How does it work in terms of
communication or spelling out
words on the board? Is there
something that points to different
letters? 10:21

You have your fingers on an upside-

20:49

last seen today at 20:00

> You
> What did the one you didn't know have to
> say? Did they mention where they were?

I can't remember but the vibe was
bad!
 10:58

In what way bad? 10:58

And do you really feel the glass
move? How powerful does it feel?
 10:59

It was angry and we felt scared,
with we were smiling and it
felt light
 10:59

> You
> And do you really feel the glass move?
> How powerful does it feel?

It moves completely across the
board entirely on its own. Hard to
believe I know.
 10:59

Like even without fingers on it?
 11:00

Now I think back I reckon it's jinn
who just mess with people 11:00

20:49

last seen today at 20:00

You
Like even without fingers on it?

You can't take your fingers off –
that's how it stays with you but it's
just a light two fingers on top of
the glass flat – you're not moving it
yourself 11:01

What makes you think it could be
jinn? 11:02

I don't think the souls of dead
people are around us... but I believe
jinn live alongside us. Like people,
some are good and some aren't
 11:03

Jinn can see us but for the most
part we can't see them 11:03

I know of people who have been
possessed by jinn though and it's
like an exorcism they have to go
through... really scary but it
happens 11:04

So they could know things about
our biographies in a way, or peo-
ple we knew? 11:04

21:56

Mon 10 Jan

We asked if there was a God and he
said 'yes'
We asked if everyone goes where he
was and he said 'no'
We asked if he was happy and he
said 'yes'
I asked what we were watching at his
house when we visited and he spelt
out 'Xena Princess Warrior'
I asked what restaurant we met at for
dinner before he passed and he spelt
out 'Brilliant'... do you remember we
all went together and then in the
limousine I think?
I asked what flavour lollipop we
were fighting over and he spelt out
'blueberry'
I asked how old he was and he said
'10'
I asked if he had any messages
for anyone but I couldn't make out
what he was saying... there was one
point where he was just moving the
glass around at random like he was
playing... I didn't feel scared. He said
goodbye without resistance

22:58

last seen today at 20:00

Were there spirits that came through that didn't identify themselves?
09:20

Yes, there was one who we couldn't identify and on that occasion it kept trying to move the glass off the board – we stopped after that because we were really freaked out – my friend talked it round
09:21

Still can't believe this happened
09:22

What made you guys choose the park?
09:22

Just a place we used to hang out anyway on Friday nights
09:23

What happens if the glass moves off the board?
09:24

Apparently the spirit stays with you
09:24

Was this your first time doing this? Is it your friend who knew what to do?
09:25

01.6.22, 01:11
I was with Laurie I think. A lioness
had escaped and ran towards us. I
didn't know what to do, so I tried
to stay still but felt like it was
constricting me somehow, like I
could feel all of its weight on me.
I remember wondering if it was a
jinn. I realised there was hair stuck
in my mouth and around the tongue
piercing I seemed to have.

Southall

Southall

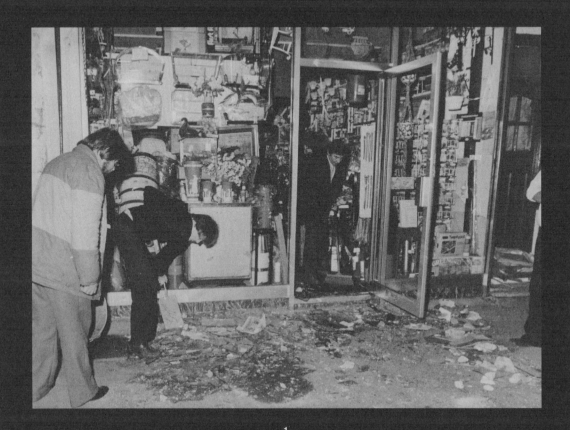

1

1 Destroyed shop front on Southall Broadway, *c.* 1979. Archival image
 of Kamaljit Sahib, photographer unknown.
2 Three commemorative plaques installed outside Southall Town Hall
 on 13 July 2021 following their previous theft.
3 Celia Stubbs, partner of Blair Peach, speaking to a crowd outside
 Southall Town Hall with Suresh Grover in the background, 13 July 2021.

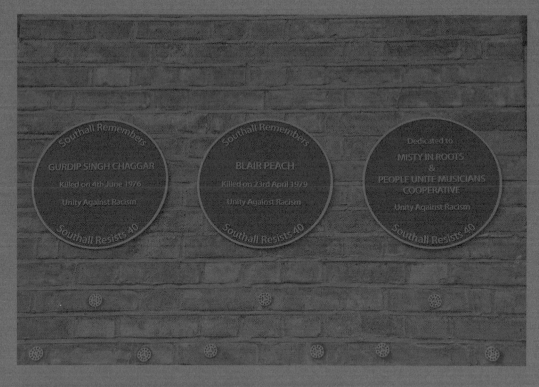

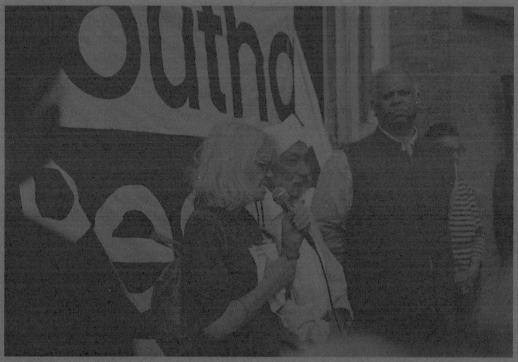

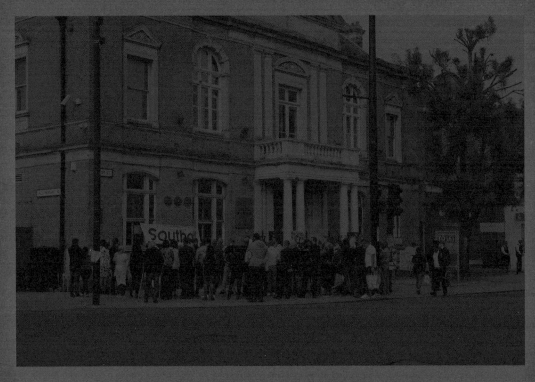

4

4 A crowd gathers outside Southall Town Hall for the unveiling of the
 plaques, 13 July 2021.
5 The death of Blair Peach. GB. England. Southall. 1979.
 © Chris Steele-Perkins/Magnum Photos
6 'Gurdip Singh Chaggar was murdered here in June 1976 (Chris
 Davies Network)'. Image from *Southall: The Birth of a Black
 Community*, the Institute of Race Relations and Southall Rights
 © Campaign Against Racism and Fascism, 1981.

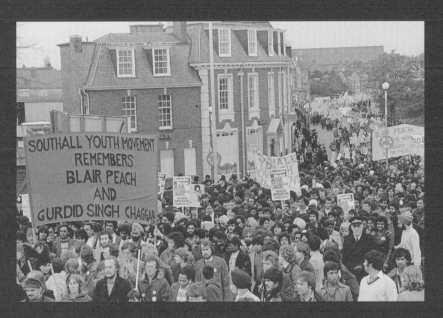

5

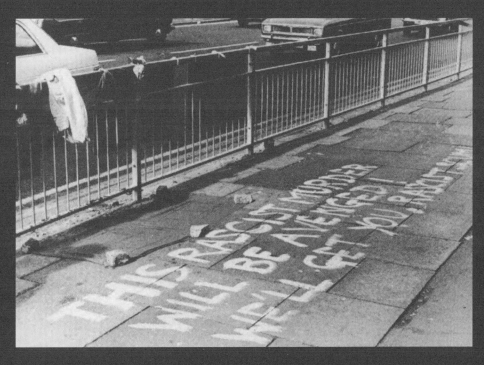

6

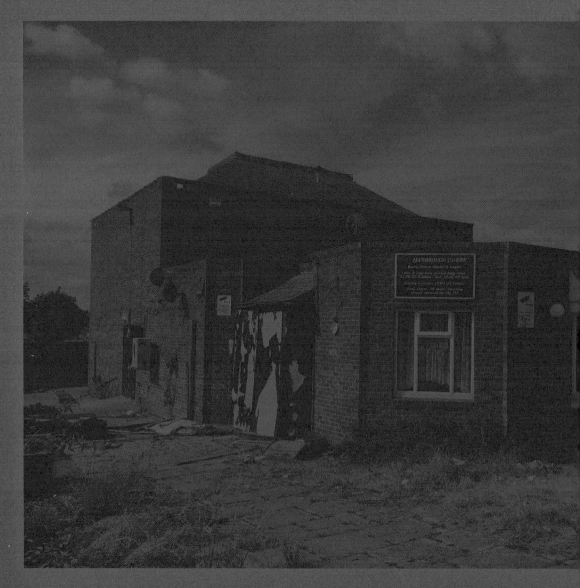

7

7–8 The Hambrough Tavern, 4 August 2022.

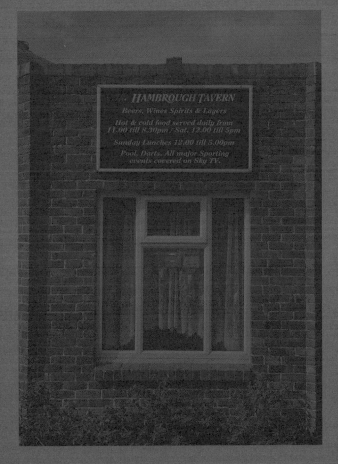

8

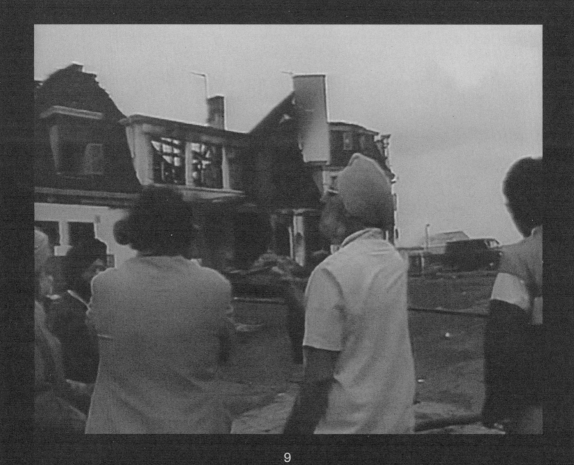

9

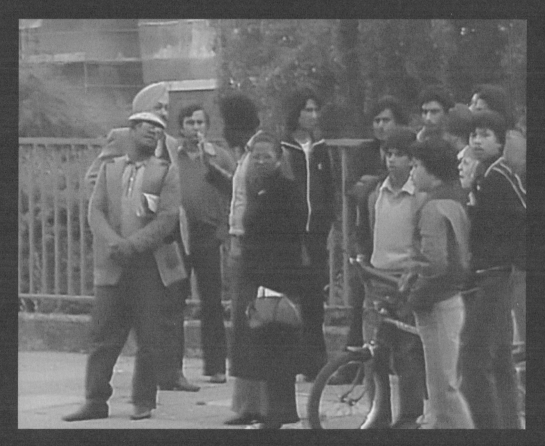

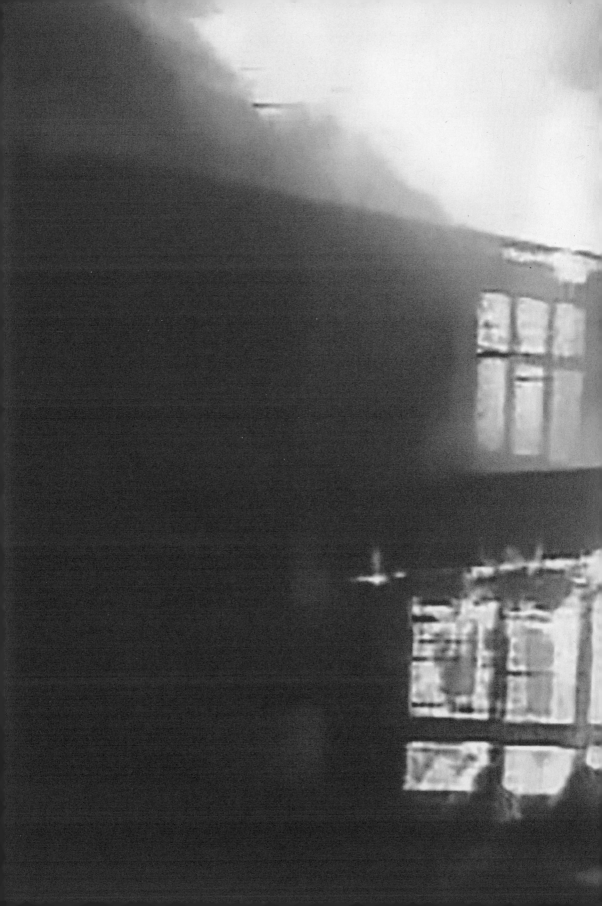

12

12 The view opposite Southall Rail Station, 4 August 2022.
13 Hoarding for The Green Quarter by Berkeley Group, on the site of the
 former gas works, Southall, 4 August 2022.

14

15

14–15 Burnt debris on the site of the Hambrough Tavern, 4 August 2022.

16

16 Paintings temporarily placed outside Southall Town Hall on the
 occasion of the unveiling of the plaques, 13 July 2021.
17 (Over page) Attendees to the unveiling of the plaques, Southall
 Town Hall, 13 July 2021.

SITA BALANI

Descend
Dissent
Ascend
Assent

DESCEND

Down into the tunnel. A bottle of fizzy water in my hand, sunglasses on, the tint smoothing the transition from milky sunlight to flickering fluorescent strips. Their glitching melds with last night's afterburn. A rave behind Angel station, a slice of London where all seediness seems long since built over, except at Electrowerkz where I danced in the low glistening sweat of a crowd of men, gurning and pulsing around our smaller, softer crew. We biked back to South London, my lover peeling off to stand and gulp the dawn air on London Bridge, my housemate and I pushing on to Borough and down through Burgess Park into Camberwell. Up the hill and into bed, a Valium tipping me into sleep.

A few hours later and I'm back on my bike, running too late for the bus, and needing to feel the wind whip my skin before I descend into the Sunday murk at Waterloo station. The Jubilee line is the smoothest way to get to the North West suburbs; you avoid the shudders and jolts of the Metropolitan. My cousins live a ten-minute drive from the line's very end. Before it picks me up at Waterloo, the Jubilee line threads through South East London and has picked up several carriages worth of Millwall fans. They are the perverse doubles of the men with whom I danced just a few hours ago, the sweaty MDMA release replaced with booze and coke. I try not to draw attention to myself. Sip my water. Wait for them to get off at Wembley. Roll on to Stanmore where my dad is waiting. Even fifteen years after he has stopped smoking, I'm somehow still surprised to find him without a fag in his mouth. He clocks the sunglasses – late night was it? I grimace and he cuts the engine, steps out to buy me a coffee.

It has been a year since my uncle passed. In my family, men divide into two categories: those who are near silent and those who never stop talking. He was the former, so in many ways almost a stranger to me, despite having spent many Sundays in the same space. This is the final mourning ceremony for him, a havan – a ritual fire. Disoriented though I am by my comedown, and however little I truly knew of him, I couldn't miss it. Something brings me back to these suburban streets that's not so different from what draws me to the rave. All of it, the day, the dawn, the train, the fire, feels like a kind of inheritance.

DISSENT

Dissent is our inheritance too, or it can be. Everyone is always searching for an ancestor, a legitimate claim. I suspect my forebears were mostly petty collaborators. But dissent is our inheritance nonetheless, simply because we inhabit the space carved out by others. We live the freedoms that they stole or won or pulled writhing into existence. We live them in sweet ignorance, as nothing less than our birthright, and perhaps that is okay. Perhaps the question is how to make ourselves worthy of that freedom, or how to win a little more for the next lot.

But for all the dreamy talk of ancestors, our immediate history is rarely discussed. The Asian Youth Movements are a case in point. They have been systematically sidelined in our official histories. What couldn't be bought off with state funding was crushed by heavy policing. Conspiracy charges and pots of money, velvet gloves and iron fists. The state formed a pincer movement, finessing old colonial tactics into a powerful strategy to disorganise a burgeoning movement. The Asian Youth Movements were more fearless than the Indian Workers Associations that came before them, cannier than the gangs they were compared to and sometimes borrowed from, and more internationalist in outlook than the left's posturing old guard. Paki-bashing wasn't stopped by policy documents, diversity trainings, or marches, but by bashing back.

In these days of packaged resistance, the fire at the Hambrough Tavern is a flare on a distant shore, barely visible, enigmatic. Even a fight over a pub as political territory exists at some remove now that most local boozers are forced to do fine dining or are converted into luxury flats. But something else is still illuminated by that distant flare. When I look at the photographs, I am reminded that action is argument and argument is action. Our dissent must itself dissent, it must refuse the lie of gradualism. History happens in leaps, not inch by inch.

ASCEND

*Resistance has a timelag, and that is because we have never been able to come to terms with the history we have made, in order to catch history on the wing and resist at that particular moment in time in a way that could bring about social change. But, the changes have come, they have added up. You don't think that the black petty bourgeoisie that we have in this country today pulled itself up by its own boot straps right? They rose on the backs of the kids who burned down the cities. Even I wouldn't be able to have a job if those kids didn't do things in Brixton and Wandsworth and Moss Side and Liverpool. That doesn't mean that that is the way forward, because we need to have constructive creative ways of changing society. — A. Sivanandan**

There's been a riot every decade. In 1981, Brixton rose just months after the New Cross Fire. In the early '90s, housing estates up and down the country rioted. It's rarely discussed, perhaps because it was mostly white kids, but the fires blazed all the same. In 2001, Bradford, Burnley, Oldham. Wanted posters in the shops and in the mosque, mothers encouraged to shop their sons, brothers, neighbours, friends. Young men put away for a decade, the state getting in shape for 2011. Mark Duggan, shot by police. A few days later, a young woman beaten. London pin-drop silent between each roar. Courts running all night to put teenagers away for nicking a bottle of water. With parasitical cunning, politicians cemented their positions by inflicting punishment. Keir Starmer oversaw the prosecutions, Boris bought a water cannon that Sadiq later sold for scrap. London stopped burning but its suburban edges still smoulder.

Now in 2022, the Tory Cabinet is full to bursting with cranks and ghouls of darker hue, and the grass outside is dry as tinder.

The world relies on the young, on their flaming courage. Who steps in if they refuse?

** Ambalavaner Sivanandan, speaking in 1987. From a trailer for 'The heart is where the battle is', a celebration of the life of A. Sivanandan (1923–2018), organised by the Institute of Race Relations: https://www.youtube.com/watch?v=j7Wl0OmAebk*

ASSENT

Knowledge, like history, gallops as often as it crawls. NO JUSTICE, JUST US. The awful fact of it lights up the room. The flick of a switch. It's like learning about mortality – you don't know and then you do. There is no one coming to save us. No NGO or government. No parent or teacher. No artwork or algorithm. Everything is terrible and everything is ours.

So come out into the street, quiet as a house cat to taste the tang of morning. Sip tea on a front step washed with sunlight. Inhale the fumes of Southall's endless choking traffic. Watch the smooth back of the dawn rise from the canal. List to the sweet thud of footsteps on suburban streets the moment a k-hole opens a portal to the sky. Let the sordid curl of history stroke your exposed throat. Cast disorder into physical forms, great hulking sculptures, so that we might take cover in their shade. Shuffle into a cubicle behind the man with the face of an angel. Pour cement into a crenulate mould and let us run our fingers along the ridges. Pencil family lore between lines of local newsprint and forget it's there. Softly, firmly, assent.

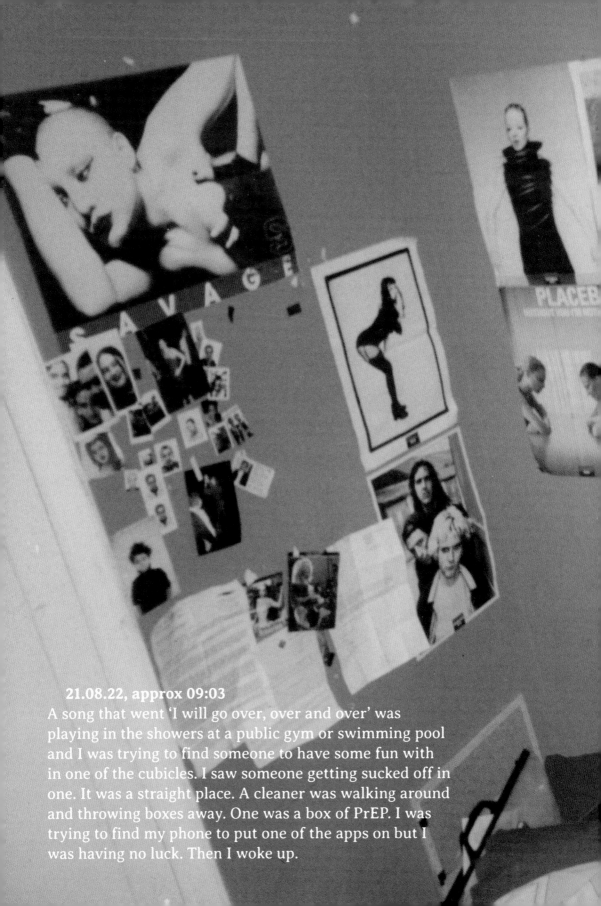

21.08.22, approx 09:03
A song that went 'I will go over, over and over' was
playing in the showers at a public gym or swimming pool
and I was trying to find someone to have some fun with
in one of the cubicles. I saw someone getting sucked off in
one. It was a straight place. A cleaner was walking around
and throwing boxes away. One was a box of PrEP. I was
trying to find my phone to put one of the apps on but I
was having no luck. Then I woke up.

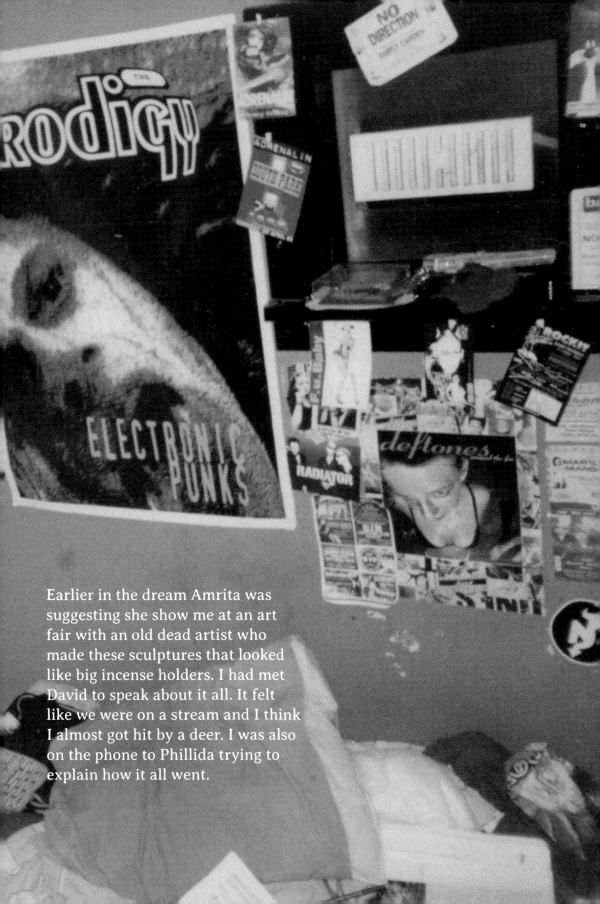

Earlier in the dream Amrita was suggesting she show me at an art fair with an old dead artist who made these sculptures that looked like big incense holders. I had met David to speak about it all. It felt like we were on a stream and I think I almost got hit by a deer. I was also on the phone to Phillida trying to explain how it all went.

Preface

There are many Southalls: black communities built on the rubble of decaying inner cities. This is the story of one of them.

The labour that Britain drew from Asia and the Caribbean helped first to bind its wounds of war and then set it on the road to recovery. Black workers swept and cleaned the cities, ran the transport services, manned – and womanned – the Health Service, worked the foundries, factories and mills, sustaining old industries and helping the new to lift off. They were the aid, the Marshall Plan, on which Britain's immediate post-war prosperity was founded. And yet they themselves were kept from that prosperity, from a stake in that society and, by virtue of the work and housing afforded them, the virtue of their colour, condemned to live midst the detritus of inner cities.

But from those very handicaps – from the 'rocks, moss, stonecrop, iron, merds' of the urban ghetto, against the unwavering racism of governments, employers, unions, police and courts – with little more than the traditions and strengths they had brought with them – black people built themselves their communities.

And it is the knowledge and pride of that achievement that binds the communities of Brick Lane, Brixton, Southall, Moss Side, Lumb Lane, Chapeltown, Handsworth and makes them 'no go' areas for police harassment and fascist tyranny alike.

A. Sivanandan
Director
Institute of Race Relations
July 1981

29.05.22, approx 10:20

I was on a boat or a plane and had to record
some lines for a surprise song that was being
produced to celebrate Madonna's birthday. There
were only two lines I had to sing, but one was in
Spanish so I was struggling. Xavi was there too
trying to help me but I kept getting frustrated
on the first word which sounded something like
'margaritadelorniastro'. The person from the
record company brought a microphone on a stand
along with a bottle of champagne. The cork almost
hit her face when she opened it. She poured us
both a glass and I drank it through a straw. I
wondered if this is what celebrities do every day.

Earlier in the dream I had met Milovan
on an island but I didn't have the right
clothes I needed for an event. I think I had
skirts that didn't match tops or I had left
some things behind. I was there painting
a city that looked like it was sinking and
smouldering into a big bay and I was using
watercolours. I remember all these lights
and smoke in a sinking pit. I started to
paint on my face and body too. It reminded
me of my Cyberdog days.

I remember mum and Manuel being there in an earlier dream where we were visiting some houses that looked like places some of our family had once lived in. They looked like regular houses but made of straw.

There was also some stress that I can't fully remember, about two rocks of ketamine and a suitcase.

I think I had a lesion appear somewhere on my body and I started getting stressed that it was monkeypox.

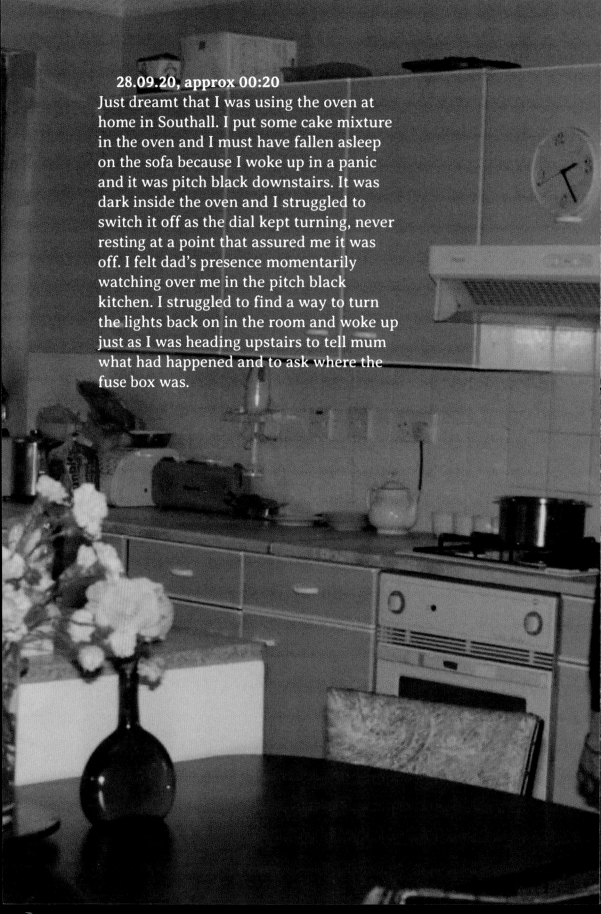

28.09.20, approx 00:20
Just dreamt that I was using the oven at
home in Southall. I put some cake mixture
in the oven and I must have fallen asleep
on the sofa because I woke up in a panic
and it was pitch black downstairs. It was
dark inside the oven and I struggled to
switch it off as the dial kept turning, never
resting at a point that assured me it was
off. I felt dad's presence momentarily
watching over me in the pitch black
kitchen. I struggled to find a way to turn
the lights back on in the room and woke up
just as I was heading upstairs to tell mum
what had happened and to ask where the
fuse box was.

16.06.22
Last night I dreamt that Eddie was a vet and I was trying to convince him to inject me with ketamine. Tonight I fell asleep on the sofa and dreamt I was at home in Southall. We were getting the house clean and tidy for Mrs Lam and her family to come around. I remember shaking Peter's hand and I was about to hug Mrs Lam but then realised everyone was trying to keep their distance because of Covid. I remember doing the dishes in the kitchen at one point and then tidying up around the boiler. Coco was so excited when they came in that she was jumping all over the place.

03.10.22

I was walking down Southall Broadway with mum and Zarina. I think they had both attended a meeting or conference. Mum was singing and began going off tune, then we heard gun shots and it immediately became dark, like it was night-time. All of a sudden it felt like we were on a set. We ran down a side road and the shadows became more pronounced and extreme as though we were on a stage. Everything went quiet apart from the footsteps of the gunman behind us. We stood quivering, frozen and facing a wall. I turned around and saw his silhouette right there. I woke up before he shot.

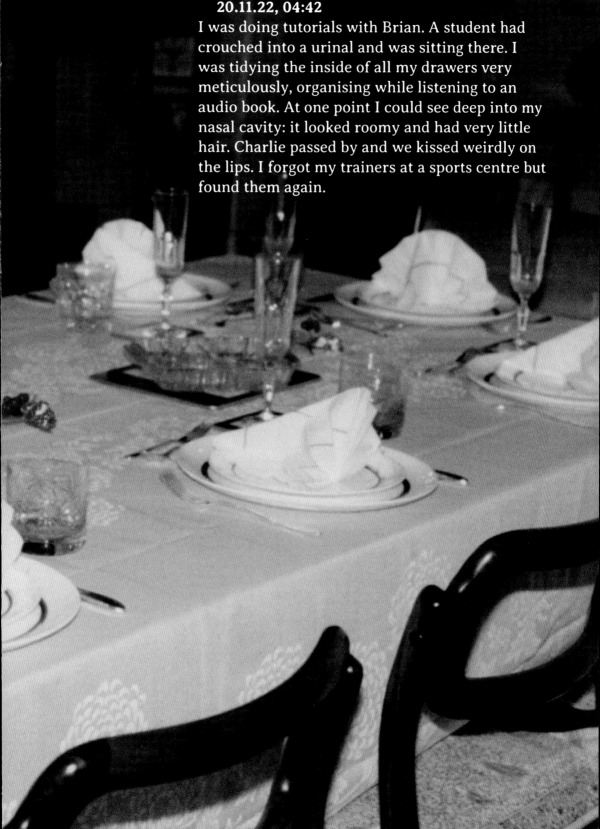

20.11.22, 04:42

I was doing tutorials with Brian. A student had crouched into a urinal and was sitting there. I was tidying the inside of all my drawers very meticulously, organising while listening to an audio book. At one point I could see deep into my nasal cavity: it looked roomy and had very little hair. Charlie passed by and we kissed weirdly on the lips. I forgot my trainers at a sports centre but found them again.

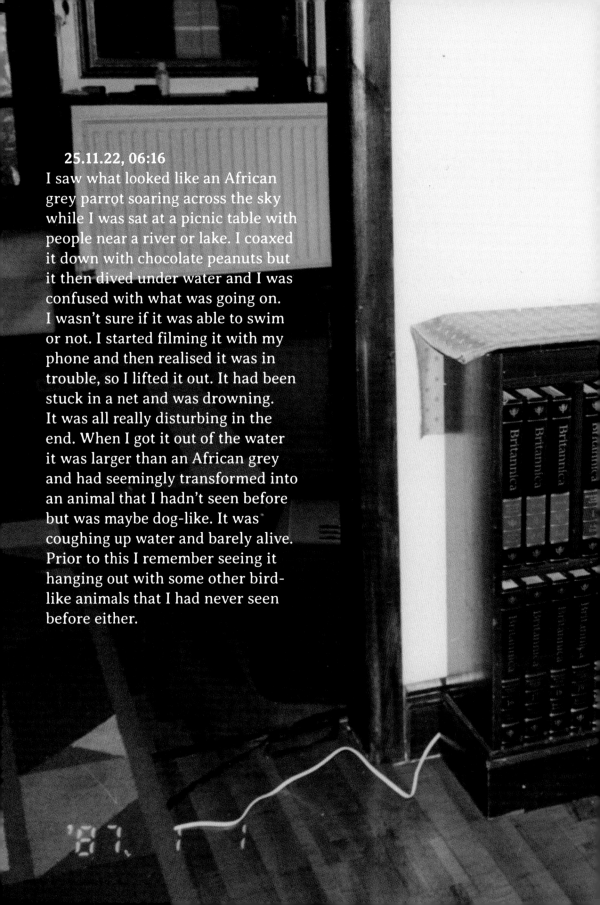

25.11.22, 06:16
I saw what looked like an African
grey parrot soaring across the sky
while I was sat at a picnic table with
people near a river or lake. I coaxed
it down with chocolate peanuts but
it then dived under water and I was
confused with what was going on.
I wasn't sure if it was able to swim
or not. I started filming it with my
phone and then realised it was in
trouble, so I lifted it out. It had been
stuck in a net and was drowning.
It was all really disturbing in the
end. When I got it out of the water
it was larger than an African grey
and had seemingly transformed into
an animal that I hadn't seen before
but was maybe dog-like. It was
coughing up water and barely alive.
Prior to this I remember seeing it
hanging out with some other bird-
like animals that I had never seen
before either.

11:34

last seen today at 20:00

What was your earliest memory or experience with them? 11:38

Thu 13 Jan

Hi Prem hope you're well and sorry for the late reply! 10:01

My earliest memory of dealing with the police was during the summer holidays of my first year at high school so I would have been 12 years old. They stopped and searched me at the top of our street as I was going out to meet my friends. 10:02

The following year when I'd just turned 13 I got arrested for criminal damage, as you know I was into graffiti so I was stupidly tagging a bus stop with a sharpie pen when an off-duty officer walked past and called the police... I was arrested, spent the whole day in the cell... mum had to come and get me, I can remember her being very upset... 10:04

Were you alone when that

158

11:34

last seen today at 20:00

Thu 13 Jan 10:04

Were you alone when that
happened or with friends?
10:48

Do you remember where it was?
10:48

Hi Prem hope you're well and sorry for the
late reply!

No worries at all.
thanks so much. Let's just chat here
as and when works for you!
10:49

Yes, the first time I got stopped and
searched I was with a friend

The second time was with two
friends in Southall, they handcuffed
me and took me in the van to
Hounslow police station 10:52

Do you remember what year that
would have been? 10:52

2003

11:24

last seen today at 13:21

Was being stopped and searched
something that happened often for
you and friends?

Pff, as a teen, literally once a week
minimum... it started to happen so
often I would ask them for a slip so
that if I got stopped again that day
I could show them I'd already been
searched... they'd usually say they
could smell cannabis (impossible
at that time) and were searching us
under the misuse of drugs act 11:01

where was it happening? 15:28

Local area, Southall 15:53

did it feel targeted? 16:12

Sat 15 Jan

Yes it was profiling 23:25

The area had a crime problem so if
you were a youngster hanging out
you would get stopped and
searched 23:27

13:24

last seen today at 20:00

Sun 16 Jan

do you know what kinda crime
problems? 22:37

Mon 17 Jan

Mainly drugs and robbery 08:59

I got robbed 3 times as a teen for
my phone and once for a camera,
twice with a knife 09:02

did you feel like you could go to
the police when that happened?
 10:33

Wed 2 Feb

How are you guys feeling?
Any better?? 09:27

Thur 8 Feb

You deleted this message
 10:49

Do you remember where you were
when you were robbed with a
knife? 10:49

13:25

last seen today at 13:21

Yeah, it was down school passage –
the alleyway between our primary
school and the police station, I was
in my first year of high school 11:41

Dad was stabbed in the same alley
back in the day 11:42

do you know much about what
happened? Did you ever speak to
him about it? 15:17

He got stabbed in the arm trying to
block the knife. He had a big scar,
he said it was a racist attack by
some NF members 18:01

I thought it was his leg 18:01

I remember there being a big scar on
his arm – I thought he said that
was from when he was stabbed?
Could be wrong 18:02

Tuesday

Did you tell mum and dad when
that happened? Funny how the
police station is right by that alley...

24.11.20

I was in the house with mum and Babcia.
They were in the garden mostly. Babcia
was even using a scooter. Coco was there
too. She was having a shit behind the shed.
I heard a noise and noticed other family in
the house. I questioned them about how
they got in without a key, as I was worried
I'd left the door open or that it wasn't
properly secure, but they didn't respond.
One of them smugly eclipsed my question
with news that they were pregnant.

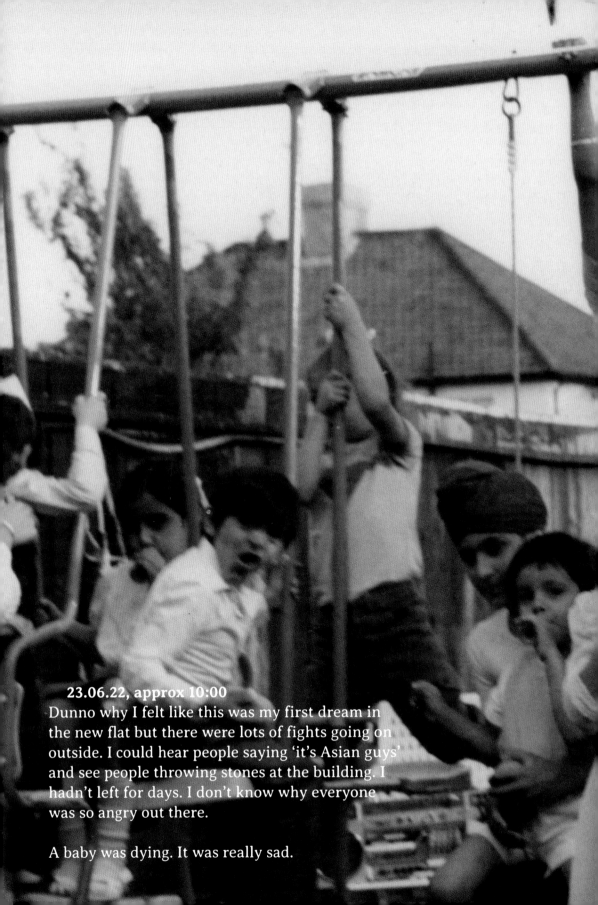

23.06.22, approx 10:00
Dunno why I felt like this was my first dream in the new flat but there were lots of fights going on outside. I could hear people saying 'it's Asian guys' and see people throwing stones at the building. I hadn't left for days. I don't know why everyone was so angry out there.

A baby was dying. It was really sad.

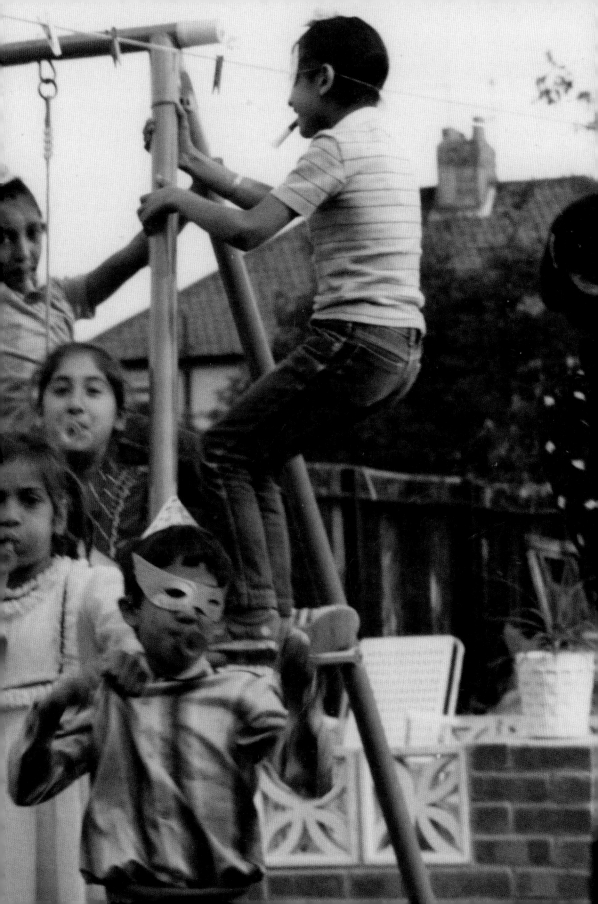

08.07.22, 00:38
I was being tested and I think I came back positive for
three things but they wouldn't say what. The doctor did a
prick test and couldn't get any blood out of my finger. At
the same time a weird metal thing was put on my nose,
it went inside too. Then this strange glove full of pins
was put over my head. It was all happening so quickly
and things were falling off. I was concerned my nose
was going to be damaged. I was offered the monkeypox
vaccine. Earlier I think Peter gave me a hug.

07.07.22, 06:38
I was getting mugged for a large bottle of perfume but I managed to get it back. Then I got jumped again at the top of the cul-de-sac and I was trying to fight them off me.

I had my family history as far back as the thirteenth century listed on a single page.

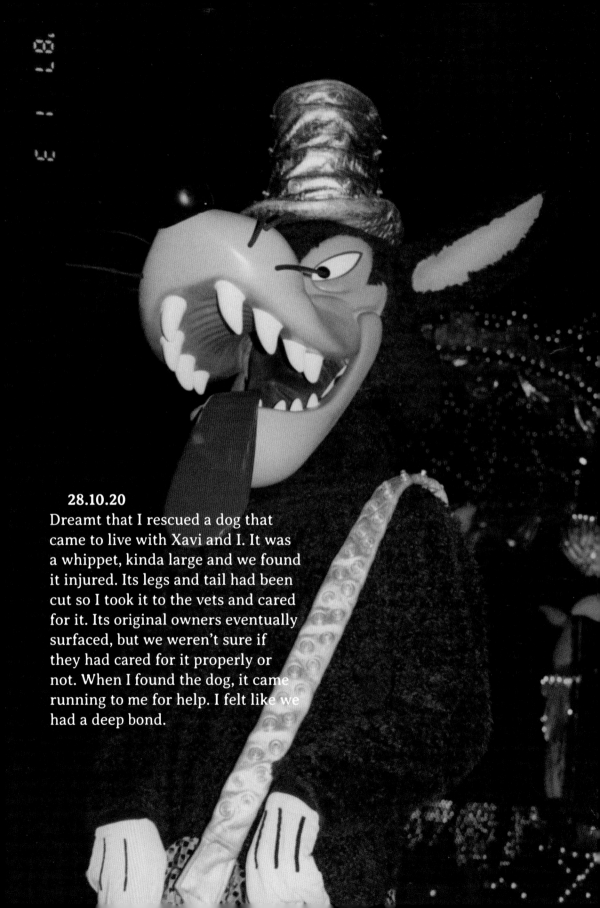

28.10.20
Dreamt that I rescued a dog that
came to live with Xavi and I. It was
a whippet, kinda large and we found
it injured. Its legs and tail had been
cut so I took it to the vets and cared
for it. Its original owners eventually
surfaced, but we weren't sure if
they had cared for it properly or
not. When I found the dog, it came
running to me for help. I felt like we
had a deep bond.

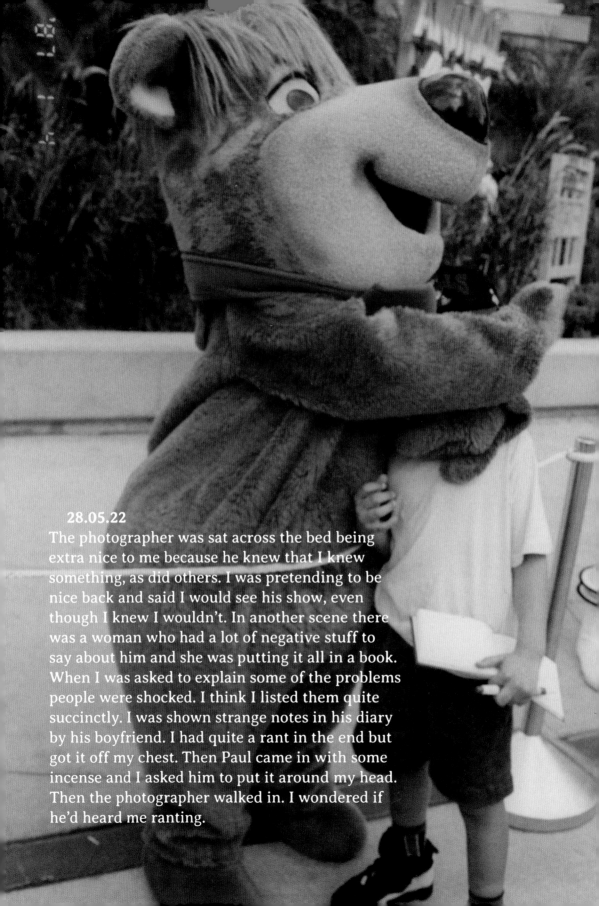

28.05.22
The photographer was sat across the bed being extra nice to me because he knew that I knew something, as did others. I was pretending to be nice back and said I would see his show, even though I knew I wouldn't. In another scene there was a woman who had a lot of negative stuff to say about him and she was putting it all in a book. When I was asked to explain some of the problems people were shocked. I think I listed them quite succinctly. I was shown strange notes in his diary by his boyfriend. I had quite a rant in the end but got it off my chest. Then Paul came in with some incense and I asked him to put it around my head. Then the photographer walked in. I wondered if he'd heard me ranting.

15.5.22, 04:54

I met a random group of people on the
train but we all got along. They seemed
to be coming back from a night out too.
Somehow the tube didn't stop and we
ended up in Windsor so I freaked out. I
didn't clock till later, but it was close to
where we scattered Dad's ashes. Anyway,
they offered to let me stay with them as we
ended up chatting the whole journey. I'd
been kissing one of their friends who had
actually started off by being rude to me
but then all of a sudden began straddling
me. They reminded me of Bimini but out of
drag. They had smooth skin and a forked,
leathery, thin tongue. I think their friends
felt for me somehow, because it seemed
like they were forcing themselves onto me.
I remember them wearing a red jock strap
under an oversized waistcoat. Their friends
seemed nice and were mostly American I
think. There was another guy who seemed
mega nice but we didn't get the chance to
speak. A girl from Guatemala was telling
me that she now lives and works in Jamaica
but we kept getting interrupted by the
friend who was trying to kiss me.
I then realised I had missed loads more

stops. She said she felt a connection to me
when she first saw me get on the train.
The group of friends laughed when I took
them up so quickly on the offer of letting
me stay. When they asked where I lived,
I told them I was staying with my family
in Southall. It kinda felt like an old me on
that train. Thinking back, there were some
strange characters on that trip. It was quite
an antagonistic journey. There was a racist
homophobic guy sitting next to me. At one
point I was drawing a face on a napkin, and
it looked like Rihanna. I think I was about
to write a message on the napkin to tell the
racist guy to fuck off and stop looking at
me.

Personal archive of
Kamaljit Sahib

Press Conference & Public Forum on

Young People and Policing
POLICE OPERATIONS IN SOUTHALL

** SPEAKERS **

Cllr Gareth Daniels
Southall Youth Movement
Unity of Afro-Caribbean People
Southall Monitoring Group

For many years now, the police in Southall have mounted a campaign to criminalize a whole community - targetting mainly asian and afro-caribbean youth. Southall is now presented as a community out of control which is steeped in serious criminal activity, involving a vast range of crimes and criminals.

The police have set up a special unit, which engages the services of international and UK police and intelligence agencies. The climax of police operations took place on 1st August 1989. On 'NEWS AT TEN', they claimed to have uncovered a Mafia-style crime ring operating within Southall, which linked asian communities throughout britain to systematic fraud operations. They also claimed to have made more than 140 arrests that day.

Young people are still being harassed by the police - they are picked up and arrested for no good reason.

ON FRIDAY 27th OCTOBER
4.30 to 6.30PM
DOMINION CENTRE
THE GREEN, SOUTHALL

For further information,
ring Kamaljit at 574 3843 or Suresh at 843 4333

Organised by Southall Youth Movement, Unity of Afro-Caribbean People
& the Southall Monitoring Group

We have organised this Meeting with the Youth of Southall in response to the Manner in which the police have been harassing and indeed arresting people in Southall. see the other reason is in replying to police's "Operation Shampoo" recently which only was not justified but also gave the pople of Shall a bad name. the Young people of have been chininisied by the media, they say that you the Young people have relations with the Mafia + Chinese Triad and are involved in major Drugs smuggling rings. I want to Know if you one why are you all still in Shall. Why not get your profits out move to windsor.

Notes made by Kamaljit Sahib who chaired a panel on
Young People & Policing Operations in Southall, 1989.

Why are you still hanging around
in crummy places in s like the
S.Y.M. – you should be in big
hotels sipping Champane. instead
of Coke and Pennants. Seriously Speaking
we are getting frustarated with the
manner the police are using the Stop
and Search laws to stop and harrassing.
people – We have people amongst us who
will be given an opportunity to speake of
their Experiances with the police –.

we also have amongst us

Cllr Gareth Daniels from L.B.E.
peter Sylvester from ~~SMG~~ U.A.C.P.
Suresh grover from S.M.G.
who ~~will~~ I'd like to thank
for today. and of Course you the
young people of Southall.

Thankyou.

½ hour 5' 6 PM

Front cover of *City Limits Magazine*, 5–12 October 1989,
418, DRUGS, The London Connection.

SHAMPOO OR WASH-OUT?

John Mackenzie has worked for Mackenzie Knight, a firm of solicitors in Southall, since 1980, and acted in a series of cases, from 1983-85, involving the by now notorious local 'gangs' – the Holy Smokes and Tooti Nungs. Earlier this summer, the police announced they had arrested 152 people in Southall and the Midlands, claiming to have smashed a huge international crime syndicate in the process.

MacKenzie's verdict on 'Operation Shampoo' – and the surrounding publicity is: 'It really is garbage.' Mackenzie says the point the papers missed is that 'Southall contains a number of highly sophisticated heroin smuggling operations that are bringing in millions of pounds worth of heroin a week. They are based primarily in restaurants, and the police *know*, or ought to know of their existence – have done so for years, and have done nothing about them at all. There has not been one major prosecution of a Southall based drugs-running gang at the level it should be, which is importation, since I've been there – and I believe before. On any one day of the week, I would estimate, there are millions of pounds' worth of heroin in various premises in Southall. And the police are totally complacent about it. It's not as if they don't know.'

Mackenzie alleges that certain policemen knew – and had known for years – that the Southall businessman Tarsem Singh Toor was a 'major drug smuggler'. Toor was murdered in 1986. He says the drug 'barons' are 'well placed in the ethnic community,' and 'are also extremely well-placed in the Indian political field. They have protectors who are very senior members of the Indian establishment – right up to the top – because they are part of the racket of smuggling currency out of India.'

The Holy Smokes and Tooti Nungs, Mackenzie characterises as 'groups of yahoos', rather than 'gangs'. 'Some are involved with various sorts of crime, others aren't. There's no formal set-up. They're used as runners, as street salesmen. But if you're going to tackle the drugs problem, from a policing point of view – and I don't believe there is any will to do it in this country – you don't just pick up the users and sellers on the streets. That's a complete waste of time', he says. He adds, 'The trouble is that the involvement of drugs in a complex industrial society is so much more difficult to understand than a police force can ever cope with. These gangs in Southall involve diplomats, airlines, and commercial concerns at the airport, some of which are owned by major international companies, so how far back does it go? The ramifications are enormous.'

Mackenzie's allegations cause apoplexy within the Southall community. Piara Khabra, spokesperson for the Indian Workers Association, says Mackenzie is 'held in very low esteem in the community. He should come up with evidence before making these allegations.' Kamaljeet Sahib, of the Southall Youth Movement, dismisses any suggestion that the Holy Smokes and Tooti Nungs might be part of an international Asian drugs mafia. 'Absolutely not,' he says. 'Some of these lads couldn't organise a piss-up in a brewery, never mind organise a heroin smuggling ring. They don't have the infrastructure or the capability.'

Suresh Grover, of the Southall Monitoring Project, believes the allegations are so exaggerated as to constitute an 'incitement to racial hatred.' He admits that there *are* drugs in Southall; 'kids smoke a bit of blow', but emphasises that there are very few hard drugs. He believes that many of the 'Shampoo' cases will collapse in court. According to Suresh, Customs and Excise have several safe houses in Southall to monitor drug smuggling. But he insists that where this happens, the smuggling is carried out by businessmen – not gang members. Targetting Southall's Asian youth is ridiculous, according to both Suresh and Kamaljeet, as any town near an airport would be bound to have some drugs trade. But community liaison officer Chief Inspector Dai Davies denies that Shampoo criminalised the community – and stresses that most of the Asian community is not involved in the drugs trade. 'I would resist any attempt to criminalise Asian youth in this area,' he says. 'The vast majority are peaceful and law-abiding.' ● QUENTIN McDERMOTT/NATASHA NARAYAN

'Shampoo or Wash-Out?' *City Limits Magazine*, 5–12 October 1989, 418, p. 9.

Kamaljit Sahib photographed with Suresh Grover, Gareth Daniels and
a representative for the Unity of Afro Caribbean People at a meeting on
Young People and Policing in Southall, held at the Dominion Centre, 1989.

UNITED KINGDOM

Spreading Tentacles

Two gangs of Indian youth have links with major crime syndicates

IT began last January as a routine low-level police probe into street-fights between two Asian gangs in Southall, London's largest Indian settlement. Five months into the investigation, Scotland Yard sleuths realised that beneath many street-scuffles, were the dangerous tentacles of mafia-like syndicates that operated far beyond Southall's High Street, in Birmingham, Bradford, Bombay and Karachi. Worried Yard detectives soon formed a crack team of 14 officers to launch a secret inquiry codenamed Operation Shampoo.

The results, announced last month, were astounding. The warring second generation Indian youth seemed to be part of an Asian crime syndicate with a finger in every sleazy pie—drugs, illegal immigration, credit card thefts, protection packets and frauds involving building societies, banks and insurance. The police swooped down upon 190 youths and, quite suddenly, Indians were on the list of mafias in the jungle of London's cosmopolitan underworld.

Clearly, Operation Shampoo was a sensitive project. To start with, it involved strict secrecy—arrests are still being made in a bid to bust a syndicate involving operatives in nine countries and Scotland Yard has been acting in tandem with authorities not only in India and Pakistan, but also in Canada, West Germany and Belgium. Yard detectives privately admit that booking the well-connected and wealthy bosses of the mafia may be a different proposition altogether.

At the centre of the racket are two gangs—the Tooti Nungs (have-nots) and the Holy Smokes—who had clashed sporadically on the streets of Southall over the last decade, but without any serious fall-out. The gangs are offshoots of the Southall Youth Movement (SYM), which grew out of the early '70s resistance to racial attacks by the then powerful white right-wing organisation, National Front (NF). The first gang to be formed was the Tooti Nungs, whose members were unemployed youths. The Holy Smokes was a breakaway group formed by sons of well-to-do Indian businessmen.

Said Pyare Lal Khabra, Southall-based chief of the Indian Workers Association: "The two gangs began to take the colour of caste-based groups. The Holy Smokes seemed a jat-dominated gang, while the Tooti Nungs was said to comprise supposedly lower caste youths."

Over the last two years, the two gangs had begun to openly defy the law and mark their presence on the streets of Southall, worrying police officials like Inspector Geof Bryden, the community liaison officer in the area. Said Bryden: "They had their trade marks, they would go cruising in two or three cars—either black Capris or Stags—to stimulate trouble. They would often arm themselves with knives and pickaxes. There would be disorder in pubs but at other times, they would blend in with the local population. They seemed to affect no one but themselves."

But unknown to unsuspecting locals, the two gangs had begun to grow menacingly and had become involved in serious crimes. A stunned Indian community heard the Yard disclose that the gangs indulged in:

▶ Protection rackets: they had their territories of operation marked out and, within those areas, would extort protection money from shopkeepers and restaurant-owners.

▶ Illegal immigration: immigrants were smuggled in from the subcontinent with forged passports and documents. Twenty illegal immigrants were found sheltered by the gangs. According to Scotland Yard Detective Superintendent Roy Herridge who supervised the operation, Bombay was a major link in the smuggling in of Sri Lankan immigrants. The immigrants usually seek political asylum after entering a West European country.

▶ Credit card fraud: some of the illegal immigrants found jobs as postmen and stole credit cards which were used to buy goods that would be re-sold. The fraud was put at £200,000.

▶ Bank, building society and insurance

Scotland Yard has detected that the gangs are involved in drug running and immigration rackets.

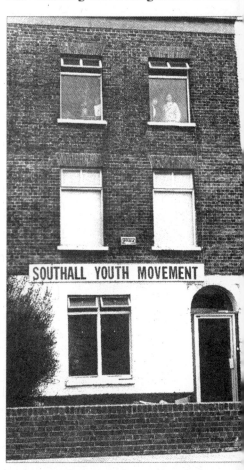

■ SYM building: embarrassing links

frauds: police busted a £4 million fraud to obtain building society loans. Other frauds were unearthed, including one involving more than £12 million.

► Drugs: the gangs smuggled in drugs, including heroin and cocaine. Detectives recovered heroin with a street value of £500,000.

At the end of the six-month-long probe, Herridge declared that violent crime in Southall had dropped by 38 per cent and robberies by 26 per cent. But he knows that nabbing the bosses may not be easy. Though he is tight-lipped about their identity, the possibility is that they are not based in Southall and are influential men. But Herridge is optimistic: "I have received 100 per cent cooperation from authorities in India, who have written to me praising the operation and I have the people's support."

ACCORDING to well-placed sources, Tooti Nungs over the years has received the patronage of some powerful figures in Southall. Unconfirmed reports associate a slain Sikh moderate with the gang while others say Tooti Nungs was paid £16,000 by a well-known figure to intervene in a dispute over the trusteeship of a gurudwara and to illegally transfer money to India. The claim if true, could throw a very different light on the activities of the gang. But said Bryden: "The claim (about their links with militants) has never been substantiated and it's not something we are looking into."

Scotland Yard was quick to defend the Indian community as a whole. "The scale of the criminal activity did surprise me, but I strongly maintain that Indians in Britain are a very peaceful community. It's only a small number of youths who has taken advantage of British laws and the peaceful nature of the Indian community," Herridge said.

But one person who is angry with the media hype over the happenings in London is Khabra. As news of the Yard's success hit the front pages of national dailies and was highlighted with characteristic verve by the tabloid press, Khabra rejected the assertion that the gangs were part of a mafia. Said he: "These were unemployed kids picked up by outsiders to act as a cover and divert police attention. This was no Mafia. The gang leaders used Southall to make money while the small fries got the blame."

That's an argument which finds support. According to the last census taken in 1981, 9.1 per cent of Southall's male Asian population is unemployed—a proportion described by local politicians as "quite high". Also influencing Southall's perception of the arrests has been the fact that Tooti Nungs was involved in efforts to physically combat the NF in pitched street battles in the early '80s, especially in protecting Indian women from harassment by front members. Said Virendra Sharma, a leading Indian member of the Labour Party, Britain's largest Opposition: "People used Tooti Nungs to give them respectability. At one time, they were thought to be the best way to strike against racism."

Sharma also admits that community leaders in the area have ignored the needs of the youth and that it was only a matter of time before the situation was exploited. "Local governments have ignored Southall for years. There are hardly any youth clubs and the pressure on youngsters to adjust to the differing life-styles at home and outside is enormous. On top of that there is the unemployment factor. We turned a blind eye to these gangs, thinking that things would be all right once they got jobs. We didn't anticipate anything like what has come out."

Operation Shampoo may have mopped up crime in the area, but it clearly has shocked Southall's estimated 80,000 Indians. Said a restaurant owner on Southall's busy High Street: "This has given us a bad name." Even so, it's an episode locals have begun to shrug off, unmindful of the heavy police presence on Southall's bustling, shop-filled lanes. It's the future they have to look to with apprehension.

—DIPANKAR DE SARKAR in London

■ Gang graffiti: rising violence and crime

■ A Southall street by night: strict police vigilance

EXECTIVE Editor.
India Today.

Dear Sir.
I refer to your article in INDIA
Today. of 15ᵗʰ Sept 1989 titled "UNITED KING
DOM" "SPREADING TENTACLES". As Representatives
of the Southall Youth Movement of which
you and your Reporters have have reported
on in the
we hearby write to inform you that
your have not only prubrlished an article
involving our organisation in the most
Slannerous manner but have been miss
informed by various people who
are self acclaimed Community
leaders. Mr Khabra being to be one of
them. Neither has Mr khabra or the
I.W.A ever S.Y.M has never had
any Links with MR Khabra or The
I.W.A. Us being the most
Radical and up comming organisations
Involving Young people is Seen as a
threat to Others, in Southall.
Your report Say's Onoting Mr K as,
the Gangs are off shoots of the
S.Y.M. I Sincearly hope that
your reporter has Some Solid Eveden
of backing up this ridiculous pea
of grabage because it is the
older generap. as far as drugs
Majour Crime is concerned it the

Draft of a letter by Kamaljit Sahib in response to the
'Spreading Tentacles' article in *India Today*, 1989.

older Generation of Buisness men
who are resposible for using the
young people. ~~oven oppressed society~~

The So called drug running is done
by ~~I~~ well to do buisness men — as
Statistics have ~~showed~~ in recent years.

& the problem of gangs involved is
& that a hand full of young people
not more than 200 out of the
Community of Southall which is 80,000
with a percentage of young being 30%
and with unemployment, policing, Housing
and Social an Economical problems are bored
with life in India and are some
what out cast of Society.

If Mr K. or the I.W.A. want to
eradicate this problem may be should
try and find out the true problems
rather that Sit in his office
giving Intervies to ~~the~~ the media.
~~all the times~~

We are in the process of getting
legal advice a for Defamation of
Character on parties involved in the
atrcl — and that you will hearing
from our Solicitors in the near future
sincealy that would alth on your
safe Reciept of ther letter.

the problems of these gangs which do not exceed 200 in numbers as opposed to the rest of the community of 80,000 people of Southall out of which 30% are represented by young people. As you will be aware that we a Blacks have to live in an oppressed society in England where rasicm still exists to a high level. Unemployment policing, Housing and social problems have made life for these youngsters very hard and the only way that they can relate to the community is by being outcasts. I can assure you that these people are not capable of organising large drugs smuggling rings. The Metropolitan police have come out with periodical statments having cracked down on these people. but we have yet to see some sort of evedence of this. We at Southall Youth Movement have since its existence created major projects where the young people have gained a high level of supervision in various fields. (I enclose our project leaflet). ON the other hand we have organisations like the I.W.A who have no facilities for the young in Southall whatso ever. it is about time that the I.W.A changes its views and ideas and opens its member ship to not only old Asian people but to the young, the Blacks the women and to even the whites.

We are in the process of obtaining legal advice at this present moment for deformation of character on all parties involved in the publication of this article and you will be hearing from them.

We sincealy hope that you acknowledge safe receipt of this ~~letter~~ and ~~So~~ ~~change the~~ republish your article removing the name of S.M Alloty as a Gesture of your misinformation.

~~Hoping to hear from you...~~

give us the right to reply as you have only got one side of the story.

← with a full article of our account

Asian Herald Friday, September 6 1991

ASIAN!

AIDS AND HIV

ASIANS in London may fall prey to their own misfortunate folly, warned Ealing Drugs Advisory Service counsellor.

Kamaljit Sahib, aged 35, currently works as an outreach worker for the service and in also involved in work related to HIV/Aids.

He said: "The asian community say, believe in God" too much, and they think it will not happen to them. They have to realise it effects everyone. Anyone who is sexually active can be affected."

He added: "They do not understand that HIV and Aids is a disease which can effect anyone at anytime of their lives."

Kamaljit has been working at the Drugs centre for over a year. Most of his work is done out on the streets of Ealing and Southall.

He admitted there were a number of asian drug addicts but not enough go into the office.

He said "I know there are a lot of people out there who we help, but they have to come to us.

"We are a very confidential service in here and outside people call us, we see them either in their homes, in schools, outside schools or in the youth clubs."

Awareness programmes are also high on his list of priorities.

Asian people needed to be informed with all the up-to-date information, which they seem to be ignorant of.

Kamal added: "As the community is very close knit, many people do not tell anyone about their addictions in case they lose respet within their community."

According to Kamaljit, the biggest problem related to addiction in the ethnic community is alcohol.

He said: "Asian men fall victims mainly to drinking alcohol — only because it is so easily available.

"Old and young people take it. I can walk down Southall Streets at 6 o'clock in the morning and find people still drinking."

As far as drugs ar concerned, it is the young asians who fall take "soft" drugs."

Kamaljit said: "It's a new scene, a new taste, a new feeling and as with alcohol easily available, and the dealers are young as well."

Parents from the ethnic community are concerned about their children's welfare, but feel helpless.

Cannabis, it seems, is the main attraction for the adolescents, but such illegal drugs have no system of being monitored for quality and quantity.

Kamaljit said: "I believe cannabis shoud be legalized, because the trouble begins when dealers muck around with the quality of the drug. Once other things are added, the problem gets worse."

Entering into the counselling profession was an easy move for Kamaljit as he has years of experience working in the asian community.

He was a worker with Southall Youth Movement and Southall Rights where he organised conferences on the subject of drug and alcohol abuse.

Summing up his aims, Kamaljit said: "Awareness, education and prevention in relation to Aids, drugs and alcohol for both the young and old has to be priority.

"Talking and discussing with the younger High School teenagers are very important. What is the point of education, if it does not help anyone? Prevention is most definitely better than cure."

He used to be a chairman of the advisory committee which helped the centre to set up two years ago.

Now working at the centre as a social worker, speaking five asian languages, which include Hindi, Punjabi, Gujarati, Swaihili and Urdu, he gains much satisfaction from helping those in need. He concluded: "This is definitely the area of work in which I shall continue."

BOOTS SEARCH BEAUTIFUL BRIDE 1991

A nationwide hunt has been launched to find the most beautiful bride in Britain.

The Boots Bride of 1991 Competition aims to discover this year's loveliest looking bride - with the weekend of a lifetime waiting to be won.

But the judges are not looking for cover girl glamour. Instead, the winning bride will be naturally beautiful, with a flair for creating a co-ordinated look with make-up, hair, jewellary and flowers.

The bride and her groom will win an all-expenses-paid, luxury weekend at the Ritz hotel in London.

Tickets to a top West End Show, £100 spending money and £100 worth of Boots gift vouchers are also included.

Two runers-up will each receive Boots vouchers worth £200 and there are £20 vouchers for 50 semi-finalists.

To enter just send in a wedding phot of the bride and groom or bride and bridesmaids.

Entry forms are available from Branches of Boots on the centre of the beautiful bride guide - which contains hints and tips on how to create the perfect wedding look.

Photos and entry forms should be sent to Boots Bride of 91 Competition, Mrs D Hamilton, The Boots Company plc, Beauty Business Centre, City Gate, Nottingham, NG2 3AA to arrive by October 20.

Anyone who wants to contact Kamaljit for further information or just a chat, can contact him at Ealing Drugs Advisory Service by phoning 081-579 5585, on Monday, Tuesday, Thursday, and Friday from 10am until 6pm.

Kamaljit Sahib, EDAS Counsellor

HELP FOR 'SAFER' DRUG USE

TURNING Points at Ealing Drug Advisory Service is a free and confidential centre.

It is funded by Ealing's local Health Authority, polic and CRUSE Aid (which is a national aids help line).

EDAS offers help to people experiencing drug related problems, whether they choose to continue using drugs or not.

The staff team is made up of a Project Manager, community psychiatric nurses, social workers (one for the asian community) and an administrator.

Friends or relatives of those with drug problems can also drop in for free advice and counselling.

The centre includes a well women's group and a library of information for those wishing to increase their knowledge and awareness of drugs, their effects and related issues.

Advice, information and counselling on safer sex, safer drug use, health issues and welfare rights are available.

EDAS is a voluntary organisation, which does not prescribe for keep drugs on the premises, so the Home Office will not be notified of any visit.

A 24 hour answer phone for messages outside office hours is also available.

For any further information contact the centre on 081-579 5585 on Monday, Tuesday, Thursday and Friday from 10am until 6pm. All enquiries are strictly confidential.

Portrait of Kamaljit Sahib, outreach worker for people affected
by drugs, alcohol and mental health issues, c. 1985.

THE GAZETTE
Friday, November 3, 1989

Sto

By ALISON WISEMA

YOUTH leaders claim
lice harassment could lea
trouble on the streets.

At a conference set up b
Southall Monitoring Group
the Southall Youth Mover
leaders claimed police
been arresting the same ye
people, two or three tim
day, for no reason.

Suresh Grover of the SM
King Street, Southall,
"The situation has become
ious with police picking
young people and

YOUTH RIOTS WARNING

Suresh Grover

LEADING youth groups in Southall have warned there could be trouble on the streets as a result of the way the area is policed.

by Karen Russell

They say conflict is brewing as young people are stopped and searched, and arrested without charge.

But police refute their claims, branding the allegations of impending violence as "nonsense."

Three of Southall's leading youth organisations united last Friday to voice their fears.

Kamaljit Sahib, of Southall Youth Movement, told a public meeting: "Loads and loads of people who have been arrested have been saying if we do not do anything about it there will be trouble in the streets."

In the wake of Operation Shampoo - a police investigation which exposed a web of drugs, fraud and fake passports resulting in the arrest of more than 140 people in Southall - he accused the police of "criminalising the

Police are accused of victimisation

young."

Peter Sylvester, of the Unity of Afro-Caribbean People, said: "People have been stopped two or three times by police officers in the space of half-an-hour. They try to criminalise every black youth before maturity."

Conspiracy

Suresh Grover, of Southall Monitoring Group, alleged the police had said the whole of the Asian and African community in Southall was involved in a conspiracy to commit fraud.

"When you throw mud it sticks," he blasted.

Describing the groups' warnings about trouble on the streets as "nonsense", Inspector Dai Davis, of Southall Police, said: "I refute it totally, and if any group has a genuine complaint there are a number of ways they can be voiced.

"If people commit crimes in Southall they will get arrested. Southall is part of Sixth Area, and each police division is policed sensitively and with the consent of the community."

S

3

harassing us

outh leaders' message to police

them all of belonging to

eems that they are doing
ecause they want a fight
something is not done
y there could be a serious
t."

f Insp Dai Davies, com-
y liaison officer, said he
ot agree with what the
s were saying and that all
were carried out with
eason.

Chief Insp Davies added:
"We will take action against
anybody who breaks the law but
when anyone is arrested it is
done as sensitively as possible.

"I do not believe these groups
are speaking for the majority of
the youth in Southall and many
young people are scared of
gangs in the town and want the
police to take a strong line with
them."

The conference, held at the

Dominion Centre, The Green,
also attacked Scotland Yard for
the wave of publicity surround-
ing Operation Shampoo -- a po-
lice crackdown which claimed
to have uncovered a Southall-
based Asian mafia with interna-
tional links in organised drug-
dealing.

Kamaljit Sahib of the SYM,
based in Featherstone Road,
Southall, said: "The media atten-
tion which the operation re-

ceived has given Southall a bad
name and criminalised our
young people."

Chief Insp Davies said he was
always willing to meet groups
to discuss policing in Southall.

Chief Insp Davies added:
"There are problems but we do
not set out to criminalise young
black people and I believe we
do a good job."

Guest speaker Cllr Gareth Da-
niel said: "Experience in South-
all demonstrates that people can
only rely on themselves to pro-
tect their community."

Left: 'Youth Riots Warning' by Karen Russell, source unknown.
Above: 'Stop harassing us' by Alison Wiseman,
The Gazette, Friday 3 November 1989.

for boys who hope to be gangleaders?

the streets

'Pathetic, miserable little clubs for petty hoodlums'

Idle youngsters can easily fall prey to the

A DETERMINED head teacher is carrying the fight to the gangs by branding them pathetic, miserable little clubs for petty minded hoodlums.

The stinging attack comes from Mrs Shirley Askew of Villiers High School in Boyd Avenue, Southall who says she is fed up with louts who try to intimidate youngsters.

She said: "It is time we let people know what these gangs are really like. We need to take the glamour out of it and show them for what they are.

"They are silly, trivial groups of boys who think they will be the gang leaders of tomorrow.

"People cannot live the rest of their lives in terror of these petty hoodlums."

Mrs Askew says the influence of the gangs is often exaggerated and only a handful of her pupils have problems.

She added: "We do have youngsters coming to us and saying pleas help us, we are on the edge of these gangs and we want to get out."

Staff at Villiers do voluntary patrols outside the school at lunch times and after hours, to keep would-be recruiters away, and are joined by the police once or twice a week.

Ugly truth about gangs page ten

Southall's other high school headteachers have echoed her condemnation of the Tooti Nung and the Holy Smoke gangs.

Trevor Davies, from Featherstone, and David Osnen, from Dormers Wells, agree the problem is often blown up out of proportion.

Mr Osen said: "We have been aware of the gang activity but it is only in a minority of youngsters."

A YOUTH worker has hit out at the constant knife fights that leave youngsters in fear as they walk the streets.

Kamal Jit Sahib from Southall Youth Movement said: "There's always someone getting beaten up or stabbed.

"The situation is getting out of hand at the moment."

"There are not enough facilities and jobs for the young so they turn to this. The problem will spread and get worse before it gets better."

Mr Sahib wants more money ploughed into Southall to give youngsters hope of work and a career.

He said: "These groups of bored boys are in a minority that want to cause trouble, but unless others see they have a chance in life the problem will multiply.

"The Southall Youth movement runs a drop-in service for teenagers offering advice on jobs and welfare rights.

Mr Sahib sees over 300 people a week and wants more groups like his given the back-

Hatred and rage bred by lives of boredom

ing to set up in Southall.

Cllr Vivendra Sharma also blames frustration and desperation for the rise in organised violence and crime, and says it is time the community rallied round.

He wants government money to help rebuild the town and sap the strength of the gangs.

PICTURES: Tim Merry, Stan James, Rob Hadley

DEC. 22. 1989

Bed-push raises £750

A YOUTH group raised £700 when they went on a marathon bed push.

Members of the Southall Youth Movement gave £350 to the Gazette's Gift of Life Appeal and £350 to the Southall branch of Mencap. Mayor of Ealing Joyce Graham went to the group's headquarters in Featherstone Road, Southall, to accept the money last week.

A dozen members of the group pushed an Ealing Hospital bed all the way from their headquarters to Hyde Park last August, collecting bucketfuls of change along the way.

Above: 'for boys who hope to be gangleaders?, the streets, "Pathetic miserable little clubs for petty hoodlums",' *The Gazette*, Friday 26 February 1988, p. 5. Above right: 'Bed-push raises £750', 22 December 1989, source unknown.

SOUTHALL & HOUNSLOW
Gazette

Friday June 1, 1990

25p

Night of the axe

Cash cuts hit Asian groups

By ALISON WISEMAN

ASIAN community groups have become the latest Tory targets after the town hall grants bill was slashed by nearly £250,000 this week.

The bulk of the cuts were made by axing grants to the major advice and support groups in Southall, including the Indian Workers' Association, Southall Monitoring Group, Southall Youth Movement and Southall Trade Union Employment and Advisory Service.

Speaking at a packed grants review meeting on Wednesday, Ealing Council leader Martin Mallam admitted that some Southall groups had been targeted for cuts.

Cllr Mallam said: "Each group has been considered on its merits. We will not give money to political groups and we do not act on the Labour philosophy that if it happens to be black it gets funded."

But the Labour group accused the Tories of bending the criteria by which grants were given to push out groups they did not like.

Labour leader John Cudmore said: "When the Tories say political, they mean groups they are prejudiced against."

The cuts mean the bulk of the advice and information work in Southall now falls on Southall Rights and the recently-merged Ealing and Southall Community Law Centres.

But the axed groups say they are determined to keep going and will offer a service on a voluntary basis.

Piara Singh Khabra, president of the Indian Workers' Association, which lost its £30,000 grant, said: "It is quite clear that these grants have been cut because they were going to ethnic organisations.

"These cuts, which have been made to punish Southall, can be seen as racist on the part of the Tories."

A crowd of shouting and jeering demonstrators from Southall community groups booed as the Tories announced cuts in money for Asian music and arts groups and hostels for the single homeless.

But the Tories surprisingly decided to back Southall Black Sisters, who deal mainly with domestic violence cases, and increase their £65,000 grant to £78,000.

Southall Black Women's Group, which runs a hostel for women and plans to open a second shelter this year, was also backed.

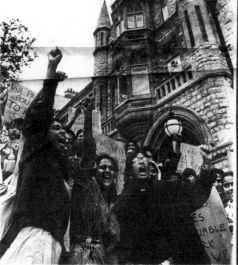

Demonstrators lobby the meeting where Tories decided to axe £250,000 grants

Cabbie held girl after row over fare

A MINI-CAB driver was so angry after a row over a fare that he drove his terrified passenger to a police station.

But the passenger Karen Allen, 21, of Ferrymead Avenue, Greenford, had no idea where she was being taken at 2.30am in the morning and fled when the car stopped at traffic lights.

The driver, Mohan Singh Kwaira, was last week found guilty of false imprisonment. Kwaira, of Carlyle Avenue, Southall, was given an 18-month prison sentence, suspended for two years, and told to pay £250 compensation to the victim and £250 costs.

Judge David Miller told him at Isleworth Crown Court: "You were working as a taxi driver and you should be able to deal with customers of all types with equanimity, however difficult that might be.

"The serious part of this case is that this was a young girl. It was around 2.30am and you drive off with her. It may have turned out she was absolutely terrified and this was a disgraceful thing to do."

The argument arose over the cab company's promotion offer, said David Ford prosecuting. He said: "This company runs a promotion scheme where they have cards in the cab. If you are not offered one of these advertising cards on completion of your journey, you are entitled to that journey free of charge." He said at the end of the journey when Miss Allen was asked for the fare she asked about the offer as she had not been given a card. A row started and the driver sped away from her home.

He even drove through a red light before she managed to escape at another set of lights the court was told.

Teenage firebugs hunt

SCHOOLBOY arsonists are thought to have caused up to £70,000 worth of damage in a blaze at a chemist.

The fire started in the storeroom at the back of Moss Chemists, The Broadway, Southall, early on Sunday evening after two boys were spotted smoking nearby.

The storeroom was destroyed by the flames while the shop and the flats above were badly damaged by smoke.

The suspects are aged 13-14, 5ft 6in, white and thin. One had blond hair with a centre parting and wore a white T-shirt with a dark collar and light blue jeans. The other wore dark blue jeans and a white T-shirt.

Jealous nurse tried to strangle ex-wife

A PSYCHIATRIC nurse driven mad by jealousy tried to strangle his ex-wife with a pair of tights.

But Mutusamy Jagernaugh, a nurse at St Bernard's Hospital, Southall, has kept his job after he called police and told them he had 'cracked.'

Mr Jagernaugh, 40, attacked his former wife Mona while she slept in the Hammersmith home they shared – but called the police when she blacked out.

Mr Jagernaugh jumped onto the 47-year-old woman who woke to find him sitting on her stomach screaming: "You don't love me. I'm going to kill you."

Mrs Jagernaugh passed out and when she recovered her ex-husband told her: "I'm going to call the police. I tried to kill you."

But Mr Jagernaugh, who has suffered a stroke since the incident, walked free from the Old Bailey after a judge gave him a suspended 12-month sentence for attempting to cause grievous bodily harm with intent. He had denied attempting to murder his ex-wife – a plea accepted by the prosecution.

John Williams, prosecuting, told how the couple had been divorced for eight months but were still living together for the sake of their ten-year-old son. But when Mrs Jagernaugh started seeing another man towards the end of last year Mrs Jagernaugh became 'consumed with jealousy'.

Things came to a head the day she bought a new blouse to wear on her birthday when she was due to see her boyfriend. Mr Jagernaugh started drinking and after his ex-wife had fallen asleep jumped on her and began throttling her with a pair of tights.

She desperately tried to argue with him before passing out. Later she begged him not to call the police but he told officers: "I wanted her to die. I just cracked. I am a psychiatric nurse myself. I know what I'm saying. What I did was deeply despicable and completely out of character."

Mrs Jagernaugh was taken to hospital and was badly scarred on the neck.

INSIDE: Viewpoint 12 Letters 14 TV 20-21 What's On 23 Classified 24-51 Sport 52-56

'Night of the axe', *Southall & Hounslow Gazette*, Friday 1 June 1990.

Oct 5 89

My Comments.

Young people were being used as mules —
but as History has it.. older business men
behind. police + customs had safe houses
any town near a port or Airport would
have drugs coming through.

—.

ITV

News At Ten
Aug 2 89 22.00

6 month Inquiry. S. Yard.
Mafia, style Crime Rings
Chinese triads, —.

Two gangs Socially, Economically.
 deprived
 areas of Southall.
 Still the Same —.
Interesting to know.
What the results were and if a
report was ever published as to the
Very Costly police Surveylance —.

Notes made by Kamaljit Sahib in response to
News at Ten feature, 5 October 1989.

Malawian Asian family housed in a four-star hotel got front page treatment by the media. As always, when such publicity is given, there was a corresponding increase in racial attacks on black people, in particular on Asians, all over the country. Black bookshops and centres and places of worship were attacked in the Southall area, as in the rest of the country. In north-east London two black students were murdered on the streets. Then, on Friday, June 4, 1976, Gurdip Singh Chaggar was attacked by a group of white youths and stabbed to death in Southall.

The murder of Chaggar, in the midst of a large and strong Asian community, was a shock to all. The fact that it had taken place outside the Dominion Cinema, a symbol of Asian self-reliance and security, gave the death an added significance. News of the murder sped through the town the following morning. By Saturday afternoon groups of angry Asian youths were collecting in the area, and in the evening outbreaks of spontaneous violence occurred – cans and stones were thrown at cars. At first the police were unprepared and outnumbered, but by 8pm they had reinforcements and began systematically to stop and search Asians, many of whom were charged with carrying offensive weapons and obstruction. This strengthened the feeling that the police were more concerned with policing the Asian community than with arresting those responsible for the murder. The youth asked the IWA to close the Dominion Cinema that evening and the next day as a mark of respect for Chaggar. They made similar requests to shops, restaurants and two other Asian cinemas in the area. The IWA asked for extra police, both to protect Asians in Southall from whites and to restrain the agitated community.

'We shall fight like lions'

The IWA had a meeting on fascism planned for the Sunday and this went ahead. Those on the platform responded to the youths' demand for action by presenting a resolution to the meeting which abstracted the event in Southall into a generalised condemnation of media and politicians: 'The present situation is the direct result of the climate of racial hysteria created by the misleading and inflammatory propaganda carried out by the NF and Mr E. Powell against the immigrants. The conference is further of the opinion that the governing political parties and the media of the country are equally to blame for the present

Southall: The Birth of a Black Community, the Institute of Race Relations and Southall Rights © Campaign Against Racism and Fascism, 1981.

situation.'

But the youth had no time for resolutions, nor for reliance on the goodwill of politicians. Nothing had come out of them in the past. Something more had to be done; there had to be immediate action and the only way was for them to organise themselves. After the meeting an impromptu demonstration was planned to march on Southall police station to 'demand protection from racial attacks'. There was no trouble until a car pulled up outside the Dominion and a white man, wielding a pickaxe handle, shouted 'You black bastards'. Then, as the youth marched to the police station, a police van window was smashed and cans and stones were thrown at cars and shops. The white community as a whole had been identified as the enemy – the youth were wild with anger. One Asian was arrested and when the youth arrived at the police station they found it barricaded. So they staged a 'sit down' outside. The youth were in command, it was they who now made the speeches. 'We shall fight like lions'* was the rallying call. After half an hour the police tried to disperse them by force and arrested another youth. The demonstrators then demanded the unconditional release of both those arrested. Eventually they were let go, one unconditionally and one on bail (though the latter was not realised at the time).

On Sunday evening another meeting was held by the youth, in the Century Cinema. Here, disaffected with the IWA and other organisations which had not been prepared to act in their defence, they differentiated themselves from their elders. It was agreed not to do anything to provoke a confrontation with the police and that there should not be indiscriminate attacks on whites, but plans were made to organise self-defence units. This meeting laid the basis for the Southall Youth Movement.

That same evening, from 8pm onwards, the police set up road blocks on four main roads in and around Southall and cars were stopped and searched. Many Asians reported that it was their cars, not those of white people, that got the attention. Callaghan, then Home Secretary, responded to the Asian leaders' appeal to speak out in support of ethnic minorities by condemning race riots instead, adding that the government would continue to oppose racialism in any form: 'I urge everyone not to allow passion to destroy our reputation as a tolerant, cohesive and unified

*The lion being the Sikh symbol of bravery.

52

ITV

NEWS AT TEN

AUGUST 2, 1989

22.00

NEWSREADER:

A six-month inquiry by Scotland Yard has uncovered two Mafia-style crime rings operating within London's Asian community. 140 people have been arrested in raids which were centred on the Southall area to the West of the capital.

We have a special report from our crime
correspondent Colin Baker.

COLIN BAKER (Reporter in West London):
Since the riots of 1981 Southall has been
regarded as a stable community. Relationships
between the police and local people are good.
Until recently some officers believed there
was little crime of any significance in their
area.

But they were wrong. Not only was there
crime...

DETECTIVE SERGEANT:
Good morning to you. Detective Sergeant...

COLIN BAKER:
...but it was highly organised.

DETECTIVE SERGEANT FOSTER:
...Sergeant Foster from the police station.
We've got a warrant to search your address.

SPEAKER 1:

Oh God.

COLIN BAKER:

It was international, it rivaled the Mafia and
the Chinese Triads in its structure. It's
made millions of pounds for its leaders who
are involved in crimes including drugs,
illegal immigrants, protection rackets and
fraud.

DETECTIVE 1:

Have a think about all the cards that you've
got and why you're here, and we'll interview
you shortly.

COLIN BAKER:

In the incident room at Ruislip detectives on
Operation Shampoo have worked for months on an
investigation that was so sensitive it was
based nine miles out of the target area. It
was so secret that many officers not involved
thought it was all about police corruption.
Even the police commander in charge refused to
believe the extent of criminality that was

involved.

DETECTIVE SUPERINTENDENT ROY HERRIDGE:

Certainly I didn't believe it. It's only as a result of my investigations since January, I've certainly discovered there is organised crime, particularly in the Asian community.

COLIN BAKER:

The first hint of organised crime came when detectives investigated a number of apparently unrelated credit card thefts.

DETECTIVE 2:

We're going to do five addresses today...

COLIN BAKER:

Gradually a pattern began to emerge, it was a pattern that linked Asian communities throughout Britain in systematic fraud. Detectives found that a card stolen in West London would be used in Southall in the morning; in Leicester at lunchtime; in Birmingham in the afternoon; in Slough in the

evening; before appearing a little later back in West London.

Early morning raids were carried out almost every day. The scope of the operation was continually expanded until eventually the investigation unearthed two Asian gangs based in West London, but operating throughout the country.

One gang called itself the Holy Smokes, the other the Tooti Nungs. Both operated separately but were involved in similar crimes: running illegal immigrants from Pakistan to Britain; smuggling heroin into this country; insurance swindles involving hundreds of thousands of pounds; and credit card frauds to raise money for drugs.

On one raid the police recovered numerous false documents, including House of Commons and Home Office note paper; birth and death certificates; driving licences and a number of foreign passports - everything necessary for a

completely new identity. All the documents were returned because it wasn't an offence to possess them, only to use them.

In this flat they search for a stolen cheque book. They also found a number of suspect credit cards, and three illegal immigrants.

DETECTIVE 3:

Well whose is this one?

SPEAKER 2:

Also my friend.

DETECTIVE 3:

So I ask you, what are you doing with that?

SPEAKER 2:

(unclear)

DETECTIVE 3:

Mr Shah, the person whose name is on that card, does he know that you've got that card?

SPEAKER 2:

Of course.

DETECTIVE 3:

Why have you got Mr Hussein's (phonetic)
driving licence?

SPEAKER 2:

I find it on the road.

DETECTIVE 3:

You found that on the road? Well I'm going to
formally arrest you on suspicion of theft of
some of these documents.

COLIN BAKER:

Rather than go through the court process and
waste public money, illegal immigrants are
more likely to be deported.

At this house a suspect car thief, a
well-known gang member, was hiding in the
loft when police arrived.

Also up there, parts from a car stolen during the night and virtually stripped during the hours of darkness. One complete car will be constructed from stolen parts and then sold. It complicates identification, making it virtually impossible for the police to find an original owner.

The chassis number on this car has been drilled out.

DETECTIVE 1:
You don't know whose car it is?

SPEAKER 3:
No.

DETECTIVE 1:
Listen, let me show you, you've got one blue Capri, one blue Capri there, one blue Capri there. You're talking about...

SPEAKER 3:
But...

DETECTIVE 1:

...let me finish, you're talking about £45,000 worth of motor when it's on the road. I think you're a bit captured this time, aren't you?

SPEAKER 3:

Mmmm.

DETECTIVE 1:

Pardon?

SPEAKER 3:

Mmmm.

DETECTIVE 1:

That's what? That's a what? That's a 'yeah' is it? All right.

COLIN BAKER:

This has been Britain's only investigation into organised crime involving Asians, principally because no one every believed the theory in the past. That is no longer the case. Detectives here have broken new ground.

In the last six months they've cut the crime rate in this area by half.

Colin Baker, News at Ten, in West London.

END

MAN DOG

But he knows the fucking British
 aren't white
You're goddamn tea *******, all of
 you
Sons of bitches, you got your sense
 of entitlement
Such unction and pretentiousness

You better believe it
You people are the most racist
 people on the planet
You think you're fucking royalty
Get the fuck out of here with your
 goddamn presumption

Well you are,
You're a fucking racist.
You're goddamn all fucking wolves in
 sheep's clothing
Or should I say fucking bulldogs
Still trying to push Americans
 around 200 years later
You think your shit don't stink
Coming on here with your high
 falutin' airs
I know everything about you fucking
 UK people
That's why I'm sending all you tea
 ******* down to Mexico
Save me the price of building a wall

Well, because we're allowed to over
 here
And if they say anything about it
 they bumped in the fucking head,
 in the back of a police car

You people were sitting ducks for
 the goddamn Russians and Germans
 when they came back to the channel
But we ain't saving your ass anymore
You fucking disarmed your goddamn
 militia

You're sitting ducks

We take little boys out and teach
 them, even girls, teach 'em how to
 use a fucking gun and shoot a duck
 when they're about eight years old
And then they keep their fucking gun
So let anybody, trying to come over
 here

I know they've all got their goddamn
 sights on the USA
Let 'em fucking
Don't mess with the US
We all got fucking guns over here

Because you fucking attacked my
 integrity
You damn racist

You're a monarchist
That's all you are
You think you have a sense of
 entitlement toward everybody

You're damn right I love Trump
That's our fearless leader
And he's divine
God has anointed him

He sits at the right hand of God
 almighty

You better believe it we all follow
 fucking Albert Pike over here,
You know what the God of the United
 States looks like?
It's right there

[inaudible]
We are the New World Order!

You remember George Washington?
He was a thirty-second degree Mason,
 he weren't stupid
He set us up as the new Roman Empire
That we should rise again for the
 seventh and last time

Well that's, you're presumptuous you
 see

I told you from the start you're
presumptuous,
And assuming is a thinking error
I think we should send all goddamn
Northern Europeans to colonise
Mexico & South America
Get rid of them…
Or whatever the fuck you call them
over there

I don't want you perverts drooling
over me and deviantly sexually
objectifying my hotness,
Christ I had to have a number all in
here the last time I had my camera
open you people drooled all over
me, it's disgusting
Er hello, I read the damn homepage
and it said this was a random chat
room for gay people
I'm here chatting randomly and I'm
here to maintain the integrity of
this chatroom
What are you doing here, besides
being a pervert?

I'm not the police, no. I'm
maintaining the integrity of this
chatroom by being a random gay
chat
If you don't like it, you can lump
it
I'll tell you what you're doing
that's perverse,
You have an unctuous sense of
entitlement for one, that's for
openers
Another thing, you're sat there like
a bump on a log and you're only
responsive to others
You have no fucking contribution
to chat whatsoever, you're merely
responsive, that's another point
I could go on and on with this shit,
all fucking day long with you
people
Quit deviantly objectifying others.
I'm not angry, that's just how I
talk, I'm an American!

We're the new superpower, we have a
sense of entitlement also
It's like the tango you understand,
you either lead, you follow, or
you step aside!

Well that's you, that's your fucking
twisted brain
You people got your head shoved up
your ass so far you can't see the
light of day over there
They cut your native son's head off
right on your native soil, and
what do you do?
You give them a voice in parliament,
Sharia law, how stupid

I don't care what you call it,
you're presumptuous anyway, you've
been brainwashed over there
You pick on Stalin and Hitler and
say that they massacred so many
million people
You see how you people twist shit,
but the real truth is, for the
matter
Is that your Winston Churchill, good
old uncle Winston the stogie,
He fucking massacred five million
fucking people through starvation
as a political tool, more than…
[inaudible]

You have your nose up everybody's
ass
The Chinese ass, the fucking Hindus'
asses, the fucking Australians'
asses, the Americans' asses,
Christ almighty, fucking stinking
little fisherman's [inaudible]
All over the fucking world, sticking
their nose up everyone's butts

You enjoy your fucking life,
presumptuous queen.
Obviously…

Fucking, I'd like to bust that
fucking cheap ass Chinese computer

over your fucking thick British
skull
Gettin' on my fucking nerves already
How in the hell, why the hell did
you come into the USA chat room
anyway, just to stir shit?
Get the fuck out of here
I'll bust a tea party on you

See that's what I mean, that's your
sense of entitlement there
You think that you're divine,
everybody wants you

I don't go to the bathhouse, or
the house of baths where I get
knighted by your imaginary queen
that gets her name from Narnia
You've never been respectful, you
goddamn come in here and harass
gay people
You're homophobic and racist.
That's not respectful, nobody wants
to be part of your twisted fucking
monarchy and your hierarchical
structure
I saw how you people built churches
over in the United States back in
the day when they were Anglican
I know, they wouldn't even allow
certain white people, classes
of white people to look at other
white people
If you didn't have money or a title,
so don't be bringing this shit
over here because we don't buy it,
So go sound crazy to some third
world country

We have a republic here, we were
built on the early Republic of
Rome
Our founding fathers intentionally
did that to kick you bastards
right in the teeth
Because they were the one with
bumbling Claudius to cripple, with
the speech impediment, one of the
weakest Caesars of the twelve, the

fucking [inaudible]
The one who hid behind the curtain
with the [inaudible]
All he had to do was fucking march
into Britain and say 'this is
mine' and that was over, imagine
that
Christ Almighty, we had to send
you fucking food, cos the goddamn
crowds were after you
Ain't gonna happen again, we're
building that fucking wall around
the whole Western Hemisphere
We're gonna just fucking invade
Mexico
We'll send all you fucking refugees
from the UK over with some Muslims
and packing
You know that's the future for you,
you're going down to fucking some
warmer climate
You're going down to get rid of 'em
fucking [inaudible]
Go down and eat your fucking Welsh
rarebit and sip your tea all day,
down in a warmer climate
Might be good for you, you seem
depressed with all them fucking
grey skies of yours
You are a ******
We can use it here, you can't,
you'll get arrested for using it
over there,
But you can come in here and harass
gay people and be homophobic can't
you?
You're racist. You just hide behind
those little laws that you make up

And we don't have that same
effeminate god you have

You're a homophobic and you're
racist
You are homophobic
You come in here and you degrade
homosexuals from other countries I
know it

You're a horrible person
No you're the disgrace
You're pretentious and unctuous
You're belligerent
You're caustic
No that's all you
You come on here looking
You got a chip on your shoulder
You got a bug up your ass
You come on here wanting to pick a
 bone with everybody all over the
 world

That's because it's true
You can't handle the truth
Come on here and try and transfer
 your abysmal attitude on me
I don't take orders from anybody
I don't know why you set yourself up
 you people
Always you pompous asses you set
 yourselves up on
You put the big hat on your head
 with the jewels on it and you
 think you're king
Get the fuck outta here

I don't love chatting to anybody
I come on here to chat randomly
To something
I don't care if you're even human
I seen a dog on here and it looked
 better than most of them
And I talked to him
I whistled at him and stuff
And he perked up and stuff
Dogs, animals, always
Pets always are photogenic
They always look good on camera
Unlike people that have ugly looks
 on their face and expressions
Because you're malicious

I'm about to open up a can of shut
 the fuck up on you too bitch
You'll have seen nothing like it

So what else do you have to
 condescend on now huh?

Let's talk about age, how come you
 haven't asked me how old I am?
So you can discriminate against age,
 or let's talk about weight
So you can see how many tonnes of
 bon bons I eat a day because you
 fuckers make me nervous on here

Why wouldn't you?
It would be consistent with
 everything else you did on here

You got anger issues it's clear

You think you had a repressed
 childhood?
Your mother put shoes on you that
 were too tight?
Didn't change your damn diapers
See what I mean? You're trying to
 transfer your shit onto me and I'm
 not buying it

[Phone beeps]
Bunch of scammers sending me text
 messages

You're a piece of shit, you better
 watch yourself
Cos your ass is going to Mexico
We're colonising Mexico, we need
 fucking fresh people like you
All the rejects of the fucking UK
 like you
You're a reject, they don't want you
 over there
You're a social pariah in the UK
So you need to start over somewhere
 again
They'll send you down there to
 fucking Mexico
Chase the fucking Indians
You can commit genocide over an
 entire race of Indigenous people
 like you did over here.

MAN DOG

Reba Maybury

One day, Prem Sahib got in touch with me about writing something for this publication. The text would reflect upon Prem's artwork; *Man Dog* (2020).

I believe Prem asked me to write about this work so that I could delve into the nuances of the protagonist's behaviour from the perspective of a woman who deals with what are popularly understood as unconventional desires. I am writing this text subjectively, from the position of an artist, writer, feminist and dominatrix. I want to first describe the work then consider what the man whose voice is recorded in *Man Dog* provokes.

With *Man Dog*, the viewer is presented with an obsidian mirror that emits the voice of a volatile American man and the faint sounds of a keyboard typing. The man's voice was recorded one day by Prem while he was visiting an online gay chatroom in 2017. This particular website randomly pairs the different men who are online so they can communicate. The intention of the website is to cater to sexual urge and spontaneity. It's cruising gone digital.

The context of the conversation is this: Prem had his camera on, but microphone off. The American man had his camera off but microphone on. Prem was presented with a black screen and a voice while he chose to communicate by typing in the chat box with his body visible.

Prem has told me that at the time of recording it was daytime for him in London which means it was either very early in the morning or very late at night for the American man. The voice of *Man Dog*, which talks for just over fifteen minutes, is stubborn. It resonates in this unmoving space with a defiant, combative air. A weaving together of generic, pathetic, absurd and even frightening statements, exposes the feelings of a gay Republican losing touch with the workings of the world outside his computer and his suburb. I imagine Prem had been expecting to enjoy his own sexuality through the chatroom; instead he was left with a random outpouring and abuse from a man from a different world to his own.

This conversation happened at the beginning of the Trump administration but we now have to understand it in the context of a Democrat in the White House. This is not to proclaim that the politics exposed in *Man Dog* have died out but rather that they have evolved and are still evolving. In many ways, what this man discusses has since somehow become normalised. It is abhorrent, predictable in its dogma for vigilant virtue, possessive in the right it claims to aggression, myopic in its distrust of humanity and laughable in its desire for a dispossession of reality.

Many of my own interactions with my submissives develop from the internet and I often think about the computer as a sexual object. Sexual release and the internet are inherently perverse because they bridge a gap between the human and the machine, the living being using a static object to stimulate. Touching the dead machine, attaching it first to electricity, then to an internet connection, enables an experience not only of endless information but also of communication. We go online with the desire to end boredom and loneliness. However, the

internet most prominently excels in producing a solitary human experience.

Through the internet's predominantly lonesome use, humans have sought an escape from day-to-day morality, and so we find individuals behaving in ways that are alien to their public and intimate personas. The resulting new forms of communication and consumption have their most prominent use in the search for sexual release. One of the internet's most commonly used functions is as a vehicle for the consumption of pornography. The internet, after all, is the greatest masturbation machine.

Online visual titillation has been accompanied by the evolution of political transgressions. This could be called the building of new power structures or, more simply, voices historically considered unimportant or unworthy (although in this case we hear the voice of a presumed to be white American man) being listened to and respected by a whole new market of people previously unable to converse so freely outside their bubbles.

Cruising has never been about conversation. I am not a gay man so as I write this I understand that my knowledge of this system is periphery but as a dominatrix I do understand the human desire for perversion, sexual relation and risk. What my submissives most often bring me is a want for conversational intimacy. They see my space as the dominatrix as one free of convention and possibly even taboo which allows the submissive to feel free to discuss what they would not with their neighbour, work colleague, or family. Sexual spaces can become a haven for the unspoken which is why they will always have the potential for radicality.

Prem's work presents the viewer with the merging of two digital phenomena of relentless controversy: sex and politics. This is not the sexiness we understand within the projected image of the curvaceous woman constructed by the media, nor the ultra-muscled and glistening gay male body. Neither is it the politics of the charisma-less, suit-wearing man, but something more feral, untamed, unglamorous and furious. This work shows

what happens when an individual's dignity loses context from anything identifiably relatable. Prem does not allow us to put an image to this man; some things do not need to be pornified. Instead, Prem wants us to listen, and in doing so we find this work horribly human.

Masturbation is not always sexual. In fact, what we hear this man generate is a frustrated desire for pseudo-intellectual political validity and also, most painfully, an emotional connection.

This man's views are not unique. His racism is predictable if not strange, littered with absurdity and ridiculous stereotyping. He is adamant for structural power redistribution, which in his manner of speaking feels parochial. At times he confirms to Sahib that he is having the interaction to 'maintain the integrity of the chatroom', as if the artist is in fact the disruptor. Seconds later, he commands Prem to acknowledge the fact that he is a 'deviant', 'objectifier' and a 'pervert'. The homophobic name calling slowly becomes ineffectual to the point of his own masochism. Man Dog then ventures into describing Trump: *Our fearless leader, he is divine, God has anointed him. He sits at the right hand of god almighty.* Sex has always been a way to reimagine your own position of power.

Man Dog's conversation tapers out into the truly delusional and pathetic. Unsurprisingly, he discloses a preference for dogs rather than humans, hence the name of the work. This is the obvious trope of those who have given up on the kindness of people. I have a strong memory of reading a newspaper article as a teenager about how in the UK, in one year, people gave more money to a single donkey shelter than they did to all of the charities for the elderly and mentally ill. The donkeys had therapy and heated stables. Perhaps Man Dog wants a world where dogs are treated well while humans are not. Perhaps he thinks that humans should work like dogs.

Sex can elicit spaces of transgression but abuses of power are always around the corner. Casual, non-compensated sex is a

place where we are supposed to play, in a momentary escape from capitalism where nothing is produced from the act other than pleasure and human connection. The internet can allow anonymity and with this a sense of freedom to do or say as you please, often with limited, if any responsibility. The gay sex chatroom is an arena of escapism from work, it teases at freedom but politics remains inescapable.

Gay men are still men, regardless of the bigotry they themselves have most probably experienced. Male homosexual assimilation, much like this man's views, is sadly predictable. Homosexuality is not a world of bountiless equality, but as Prem points out here in this work, one where hideous racism is disguised as 'preference' or 'kink', blatant misogyny is miraged as 'humour' and quiet conservatism has flourished, preferring to make life easier, more pleasant and subdued for the individual, rather than for the masses. There is nothing less erotic than a conspiracy theory.

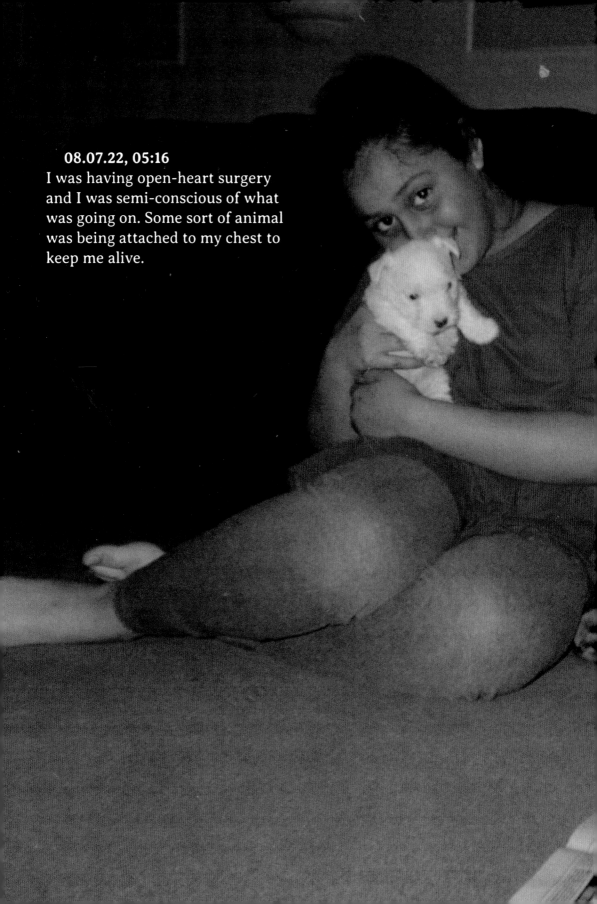

08.07.22, 05:16
I was having open-heart surgery
and I was semi-conscious of what
was going on. Some sort of animal
was being attached to my chest to
keep me alive.

13.09.22, 06.50

I dreamt that Sita was in Southall and
I'd invited her around the house to meet
everyone and we were all sitting around
the sofa eating weird 'HRH' biscuits. Coco
was alive and was being really cute. She felt
a bit bigger than I remembered her being
and we were giving her a lot of attention.
Pouji began speaking to Sita in Hindi and
I got embarrassed that maybe that was
presumptuous. I had stuck some autumnal
leaves on my face like brown tears. I was
somehow showing this to Max Allen, who
thought it was funny. Then Sita and I went
to sit at a long desk that seemed to stretch
the whole of the living room downstairs
and she began to write her text. To be
friendly I asked a question about how
things were at uni, but somehow it ended
up being awkward. I woke up thinking
about Paul's cat.

28.06.22, 06:08
Mum had long crimped hair
extensions and was singing around
the house. It felt like there was a
street party or function going on.

20.11.20
I dreamt that George and I were drunk in the shop with Princess Julia and she was wasted and started trying on all the clothes. Eventually, she ended up without any of her own clothes on because we had pinned them all to the wall. We were all in fits of laughter because we realised that we had created a version of her stuck to the wall. It was funny and a little unnerving.

06.10.20
Last night I felt like I was
on a residency where some
younger artists were making
work – drawings and collage.
It made me feel like I wasn't
capable of doing anything
myself. Sarah was there and
Katherine too. I can't really
remember too much but I
definitely had other dreams.

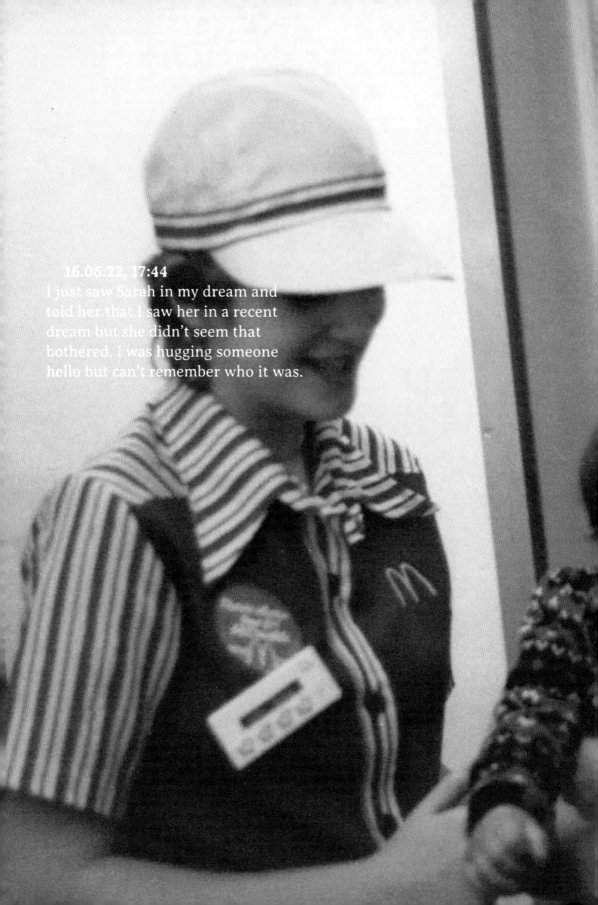

16.06.22, 17:44
I just saw Sarah in my dream and told her that I saw her in a recent dream but she didn't seem that bothered. I was hugging someone hello but can't remember who it was.

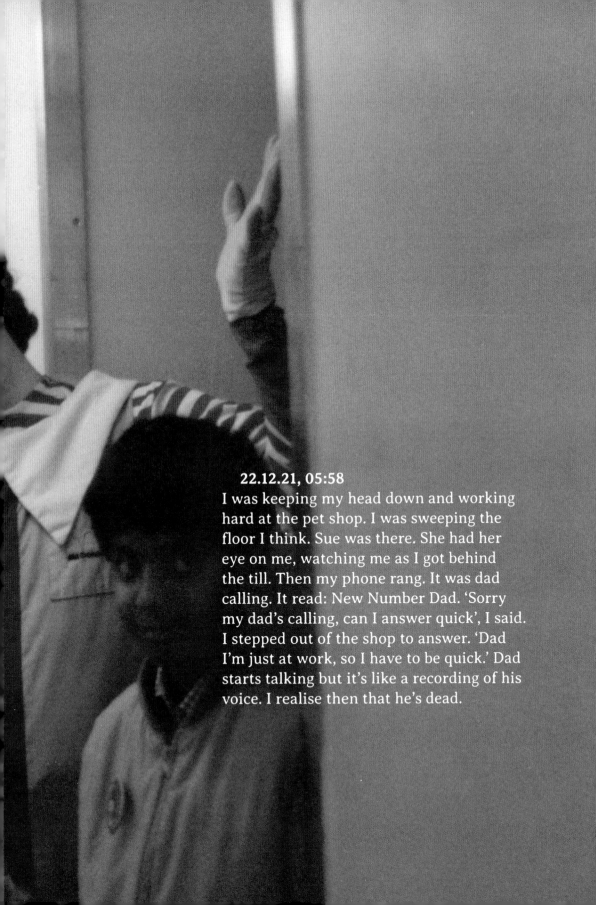

22.12.21, 05:58
I was keeping my head down and working hard at the pet shop. I was sweeping the floor I think. Sue was there. She had her eye on me, watching me as I got behind the till. Then my phone rang. It was dad calling. It read: New Number Dad. 'Sorry my dad's calling, can I answer quick', I said. I stepped out of the shop to answer. 'Dad I'm just at work, so I have to be quick.' Dad starts talking but it's like a recording of his voice. I realise then that he's dead.

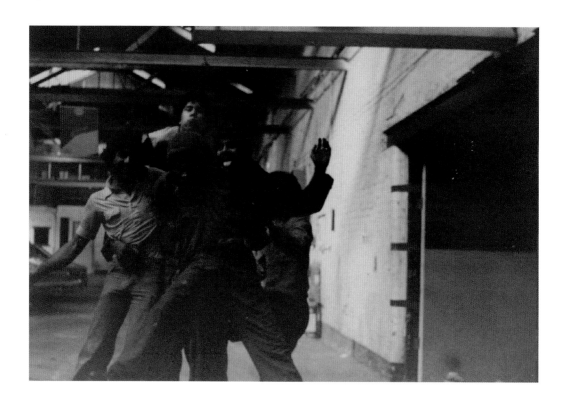

That Fire Over There
Prem Sahib

Published by Book Works
Distributed by Book Works (UK)
and Idea Books (Europe and Rest of World)

Edited by Lizzie Homersham and Paul Sammut
Designed by Martin McGrath Studio
Printed in Lithuania by Kopa
Typeset in Arno Pro Caption, Averia Serif Libre,
Neue Hass Unica Pro, and Standard Book.
Printed on Maxima Volume 150gsm and Recystar Nature 115gsm

ISBN 978 1 912570 18 8

To my family in the most expansive sense, and my parents Raj & Helen Sahib.

With special thanks to Sita Balani, Chloe Carroll, Gavin Everall, Lizzie Homersham,
Milovan Farronato, Xavi Llarch Font, Reba Maybury, Martin McGrath, Manuel Ramos,
Phillida Reid, Anika Sahib, B Sahib, Helen Sahib, Kamaljit Sahib, Ramone Sahib,
Paul Sammut, and Ashkan Sepahvand.

People Come & Go images: digital collages by Prem Sahib, using
installation photos from *i. People Come & Go*, Southard Reid, 2019
and photography by Prem Sahib, Mark Blower and Lewis Ronald.

Scans from *Southall: The Birth of a Black Community*, p. 2, 127, 197,
198, reproduced courtesy the Institute of Race Relations, London.

Book Works has attempted to contact all copyright holders but has
not always been successful. We apologise for any omissions, and if
notified we will amend in future editions.

Book Works receives National Portfolio funding from Arts Council England.
This book was realised with the generous support of Phillida Reid.

Book Works
19 Holywell Row
London
EC2A 4JB

www.bookworks.org.uk
+44 (0)20 7247 2203

Supported using public funding by

ARTS COUNCIL
ENGLAND